IMAGES
of America

SQUIRE'S WARREN JUNIOR MILITARY BAND

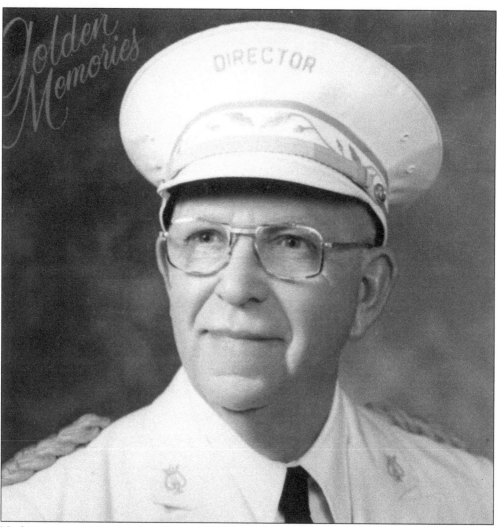

Nothing can say it better than Donald W. "Squire" Hurrelbrink's own words: "Most important to me are the kids . . . Being able to help them experience the best music, to grow up to be good American citizens and have love and respect for their Lord and their country." (Courtesy of Trudi Birk.)

ON THE COVER: The Warren Junior Military Band is seen at the 1964 New York World's Fair. Donald W. Hurrelbrink, director, is at the podium. (Courtesy of Fred Greene.)

IMAGES
of America

SQUIRE'S WARREN
JUNIOR MILITARY BAND

Janne Hurrelbrink-Bias

ARCADIA
PUBLISHING

Published by Arcadia Publishing
Charleston, South Carolina

Library of Congress Control Number: 2016962060

For all general information, please contact Arcadia Publishing:
Telephone 843-853-2070
Fax 843-853-0044
E-mail sales@arcadiapublishing.com
For customer service and orders:
Toll-Free 1-888-313-2665

Visit us on the Internet at www.arcadiapublishing.com

*This book is dedicated to the memory of my father, Donald
W. Hurrelbrink, and to all those whose lives he touched
through his music, teachings, and patriotism.*

CONTENTS

ACKNOWLEDGMENTS

The 83-year phenomena of this great organization would not have been possible without the loyalty and dedication of the directors, musicians, band managers, executive directors, band mothers, band fathers, band parents, band nurses, music arrangers, field show designers and field staffs, truck drivers, cooks, chaperones, bus drivers, fundraisers, and all the loyal alumni, many of whom returned to assist the band as instructors, announcers, fundraisers, masters of ceremonies for concerts, and in so many other ways. From the early years through the 1950s, the band received tremendous support from area Veterans of Foreign Wars and American Legion posts and from numerous city officials.

It is not possible to chronicle everything in the 83 years, but with the assistance of photographers and many alumni, memorable moments have been shared. As one of Squire's daughters, I grew up in, was a member of, and worked with the band on staff and in various capacities for nearly half a century. While I have many fond memories, it is the scrapbooks, memorabilia, and alumni that truly tell the story. All images, unless otherwise noted, came through the alumni association.

A thank-you goes to my husband, Herb, who allowed me the time, understanding, and loving support to complete this project; to Jim Cunningham and the Warren Junior Military Band Alumni Association for their support; and also to those who assisted with various chapters, especially Ruth Beatty, Judy Cartwright, Andy Gray, Wendy Mundell, Donna Hurrelbrink Pate, Mike Westmoreland, Tom Volk, and Jonathan Willis, and for the technical assistance from Missy Isler at the Photo Place, George Mazallis, Mike Shields, and the great staff at Arcadia.

INTRODUCTION

Music was an important part of community life in the 1920s and 1930s. There were orchestras and civic bands of all types: brass bands, clown bands, military bands, school bands, all-girl bands, all-boy bands, accordion bands, cornet bands, sailor and soldier bands, Scout bands, and drum and bugle corps. It was natural for bands to form around Warren, Ohio, especially with Warren being the location of the renowned Dana Institute of Music.

In 1927, Col. Lester Friend, a local post office employee and a veteran of World War I, was inspired as he watched a parade during Warren Boys' Week. At that time, St. Mary's School was discontinuing its band program due to an increasingly depressed economy. The boys from the St. Mary's Band were turning in their instruments and uniforms. With an idea, Colonel Friend appealed to the Veterans of Foreign Wars (VFW) for support. Warren VFW Post 1090 took the idea under advisement and appropriated $500 toward the project. Soon the instruments and uniforms were secured from St. Mary's and a few musicians retained. Colonel Friend, the organizer of the band, was also its first business manager until 1940. Raymond Dehnbostel, graduate of the Dana Institute of Music and former director of the St. Mary's School Band, became the first director of the VFW Boys Band. Dehnbostel quickly brought the organization to a standard of musical excellence. After three years, he left and became director of two other local bands and later was a county supervisor of music and faculty member at the Dana School of Music, then located at Youngstown College.

An unfortunate turn of events for the VFW Boys Band, which split in 1930 due to religious differences, provided a wonderful opportunity when Donald W. Hurrelbrink was named the new director at the young age of 21. What nobody knew at the time was that this new director would be there for an unbelievable 66 years!

Donald's love of music began at the age of eight when he attended a violin concert at the Toledo Museum of Art. Saving his newspaper money, he bought a violin and learned to play. French horn became Donald's instrument at Toledo Libbey High School, and he also became drum major of his high school band. In 1927, Donald came to Warren to pursue his interests and talents at the Dana Institute of Music. While there, he traveled with the Red Path Circuit, a musical entertainment troupe. After graduation, he continued his studies with Wendell Hess of the Cleveland Orchestra and at the Cincinnati Conservatory of Music, receiving his master's degree from Youngstown College.

It is not possible to talk about the band without talking about Donald W. "Squire" Hurrelbrink, as he truly was the heart and soul of the band from 1930 to 1996. Where did the name "Squire" come from? It was not long until, as director, he began wearing a white uniform. One day, someone commented. "Look, there goes the squire." The name stuck and he was affectionately called Squire for the rest of his life. A band member once wrote:

In Webster's, squire is defined as a title of dignity next in degree below knight and above gentleman. In Warren, "Squire" is the title conferred upon only one person—Donald W. Hurrelbrink, famed, skilled, and devoted director of the internationally known Warren Junior Military Band. A gentleman he is, but a driving taskmaster in demanding perfection in music. Always resplendent in concert and parade in spotless uniform, he is the image of the "white knight" of the military band field. His baton, guided by the imaginative mind of a musician, is his lance, and his unassuming character is his shield.

The band had a deep sense of community. A normal year meant 30 or more local performances, including concerts, field shows, parades, and small ensembles. Veterans Day, Memorial Day, Columbus Day, Fourth of July, Halloween, Christmas, St. Patrick's Day, candlelight vigils, military funerals, United Appeal, Scout anniversaries, Special Olympics, chamber of commerce activities, homecomings, area festivals, fairs, dignitaries, presidential candidates, and other activities were all on the agenda. With members aged 12 to 21 coming from many different schools and numerous communities, the band was sought after for many types of performances. The band was also well-traveled, performing throughout the United States, Canada, and Europe.

For Squire, the American flag and "The Star-Spangled Banner" were a major part of the band. A deep sense of commitment to our country; a love of Sousa marches and the classics; and directing and sharing the music of the great masters with band members, parents, and audiences formed the core of the band's existence. The qualities of patriotism, good sportsmanship, appreciation of good music, and the practice and dedication it takes to be a good musician became the foundation of Squire's teachings. Manners and self-discipline were stressed both on and off the field.

Many members made music their careers as band directors, professional musicians in major symphonies and opera orchestras, musicians in armed service bands, conductors, professors, pop music musicians, television musicians, composers, arrangers, and in other venues, with many continuing to play in community bands. Just as proud of their experiences were other members who went on to other vocations, for all learned the meaning of patriotism, loyalty, sincerity, and the rewards of hard work and hard play while in the band.

Squire's career also included the public school arena for 42 years and five years as a faculty member at the Dana School of Music. He retired in 1971 from public education but continued with the Warren band. No matter where, Squire's beliefs were the same:

> I believe music to be one of the greatest mind trainers in the world. A student has to think accurately and rapidly. In a band, he has to cooperate with his fellow bandsmen, to listen and coordinate his individual part to blend with others. He must be a keen listener that he may play in tune and get a sound that is pleasing to hear. He must be a self-disciplinarian. Music is one of the great arts and one of the supreme achievements of man. It is the language of the spirit—a cultural force of the greatest magnitude. Yes, music is a great force in education.

The band's name was changed from VFW Boys Band to VFW Band when girls became members and then to Warren Junior Military Band in 1957. After 1957, a board of trustees consisting of band parents, band members, and sometimes community leaders oversaw the general management of the band. Eventually, the band's social games became the major source of funding for the band's activities and travels.

The word "military" referred to the style of music and marching and, in part, to the band's patriotic spirit. Emphasis was placed not on winning but rather on doing the finest job possible and showing real sportsmanship. The band was not only a musical organization but also a wonderful opportunity for young people to live together, to learn to respect the rights of others, and to cooperate and work and play hard in order to achieve common goals. So many alumni have said the discipline received from the band and its music has carried them through life.

One

THE EARLY YEARS

The VFW Boys Band, led by Raymond Dehnbostel, was formed in 1927 with nine original members and won its first VFW National Championship with 36 members. Early highlights included representing Ohio at Pres. Herbert Hoover's inauguration; being designated as the official band for the state of Ohio; and wearing new red-and-black uniforms. With the naming of new director Donald W. Hurrelbrink in 1930, the era of annual band camps began. Locally, many concerts were played in Warren's Court House Park and in nearby cities along with parades and community festivities. With members in uniforms and girls in formals, annual military balls were begun, with local girls competing to be the band's honorary colonel for a year. The band continued to grow in numbers and performed in many Ohio cities; placed first in all-state VFW competitions; performed as guest artists for the 80th Army Division, the Chicago International Exposition, the Canadian National Exhibition, and the New York World's Fair; and played as co-artists with the US Navy Band. An invitation from Adolf Hitler for an all-expenses-paid, six-week concert tour of the "Vaterland" was declined. For VFW competitions, members traveled to Providence, Indianapolis, Milwaukee, New Orleans, Denver, Baltimore, Louisville, Buffalo, Boston, and Columbus. Winning six VFW National Championships, the band competed in the senior band division and against professional bands. Appointed several times as the official band of VFW National Encampments, it was chosen as the honor escort for World War I veterans in New Orleans and often led encampment parades, winning the VFW Most Colorful Unit trophy several times.

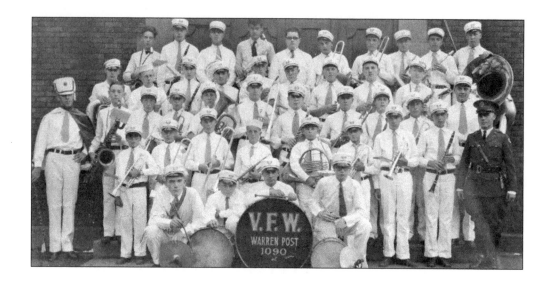

In the spring of 1927, nine boys attended the first three rehearsals of the newly formed VFW Boys Band. By May, 40 boys had successfully auditioned with instrumentation of two flutes, seven clarinets, five saxophones, two French horns, eight trumpets, seven trombones, one euphonium, two bass horns, five percussionists, and a whistler. Raymond Dehnbostel was named director, and Col. Lester Friend, organizer of the original band, became band manager. In June, the band traveled to Columbus to compete in its first state VFW encampment, winning the championship title. In September, the band captured its first VFW National Championship and also won the VFW's Most Colorful Unit trophy in Providence, Rhode Island. In 1928, a second VFW National Championship was won in Indianapolis. This original band established a tradition of excellence and dedication that lasted for 83 years. The 1927 band is pictured above; the band shown below is from 1928 or 1929. (Both, courtesy of H.G. Downs.)

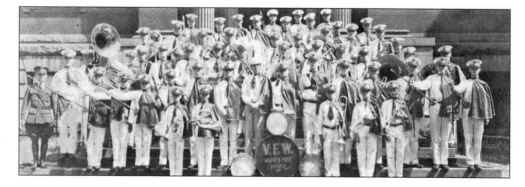

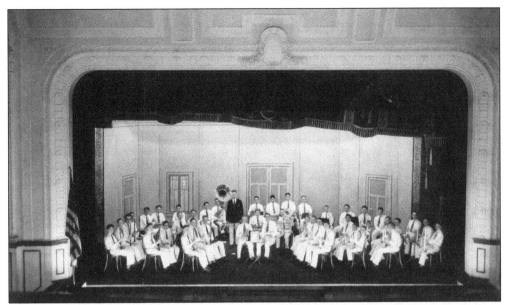

Standing in the dark uniform is the director, Raymond Dehnbostel. Konold Auditorium at Warren G. Harding High School was often the location for concerts in the early years. The band made its first recording of "Semper Fidelis" and a medley of World War I songs here. (Courtesy of H.G. Downs.)

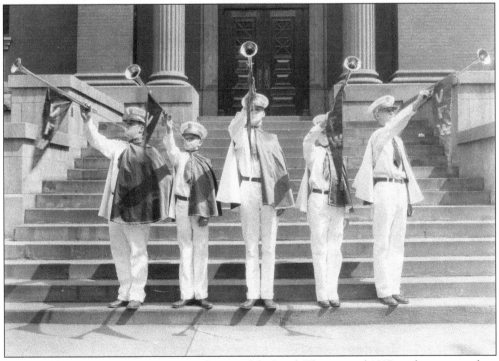

Five herald trumpeters were a signature feature of the band. The original 1927 uniforms were white trousers, belts, white shirts, ties, blue sweaters, and blue capes. For parades and field competitions, white Pershing yachting caps with a blue band and gold spread eagle were worn. The drum major carried a 26-inch ceremonial baton wrapped in red and gold cord. (Courtesy of H.G. Downs.)

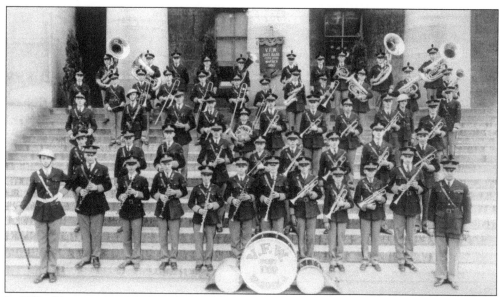

In 1929, Ohio governor Myers Cooper officially named the VFW Boys Band as the "Governor's Own." The band represented him on many occasions, including a weeklong engagement at the Ohio State Fair. Marches and Broadway tunes were popular with audiences. Band member Raymond Amy wowed everyone with his special talent of whistling the piccolo part to "Stars and Stripes Forever."

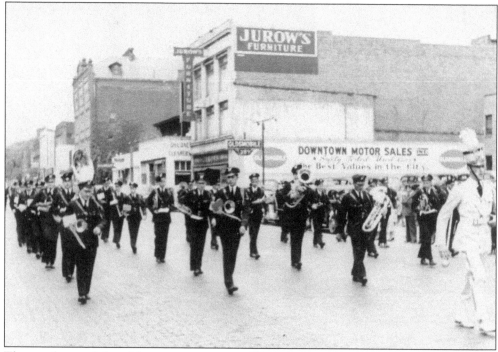

Thousands attended weekly summer concerts at Warren's Court House Park. Parades around the park were often held prior to performances. Concerts featured the VFW Boys Band and other area musical groups (pictured), sometimes two or three performing on the same day. Faculty from the Dana Institute of Music served as guest conductors.

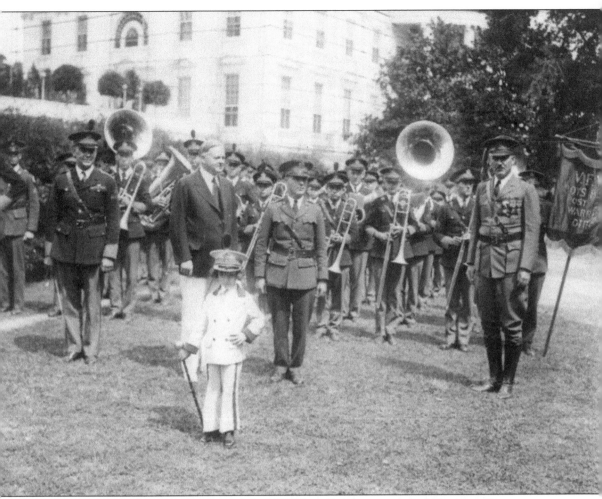

On March 4, 1929, the 68 members of the VFW Boys Band accompanied Governor Cooper to represent the state of Ohio in President Hoover's inaugural parade. Impressed by the band, President Hoover applauded enthusiastically as it marched past the reviewing stand. One of the original members recalled a downpour during the four-mile parade. Uniforms had to be laid out on the floor of the War Building to partially dry and then hustled off to the cleaners as they were needed for the band's performance at the inaugural banquet that night. The band also participated in a nationwide radio broadcast during the inauguration ceremonies. In September 1930, the band was invited back to the White House to be personally acknowledged by President Hoover. This time the band was wearing its new red-and-black uniforms. Although it was all boys, Betty Lee Parson accompanied the band for many years as their mascot. (Courtesy of Harris and Ewing.)

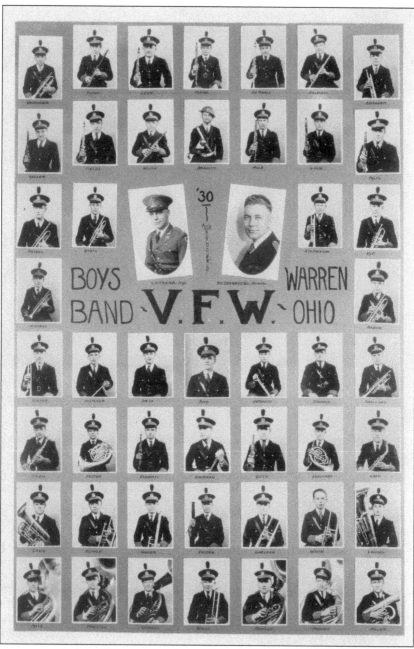

This picture was taken in 1930 with each member's name and primary instrument. The new uniforms purchased in 1929 consisted of a red coat with collar and pockets trimmed in black, pants with a red double stripe, a black leather Pershing belt, a red hat with black band and trim, and a small red plume. The center photographs show band manager Col. Lester Friend (left) and director Raymond Dehnbostel. The VFW Boys Band was extremely successful in its first three years, winning several championships. Unfortunately, in 1930, religious differences caused a division. Some of the boys stayed with Dehnbostel, who became director of the Antlers Boys Band and the Fadettes Girls Band. Friend remained with the VFW Boys Band as manager. (Courtesy of H.G. Downs.)

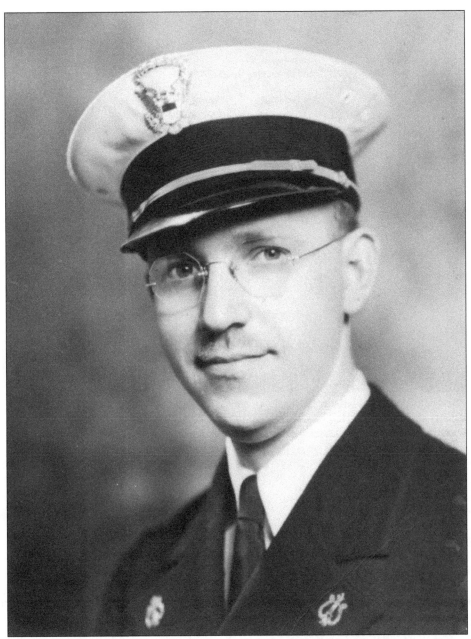

The VFW Boys Band was now without a director. In October 1930, twenty-one-year-old Donald W. Hurrelbrink was selected. He had a love of music engrained in his blood at an early age and had come to Warren, Ohio, to attend the renowned Dana Institute of Music. Learning much from Lynn Dana, Charles Lowry, and Ross Hickernell, Hurrelbrink soon knew music would be his life. The opportunity to direct the VFW Boys Band changed his life from embarking on a professional playing career to embarking on a teaching career. Never regretting his decision, he continued to play in area symphonies, but his life was devoted to teaching young musicians, instilling in them pride, dedication, and love of country. His career as director of the VFW Boys Band, later known as the Warren Junior Military Band, lasted for a magnificent 66 years. As so many members said over the years, "Thank You, Squire, for all you gave us!" (Courtesy of Printing Service, Inc.)

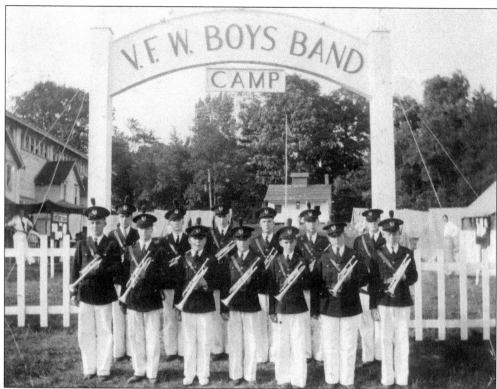

The first band camp was held in 1931 at Conneaut Lake Park, Pennsylvania; the band continued to camp there through 1941. The six-week camp was open to boys aged 10 to 20, and they could sign up for any or all of the sessions. Each weekly session cost $5, with six scholarships available for various instruments such as oboe, bassoon, tuba, flute, and French horn.

Camp awoke daily to the bugler of the day playing "Reveille" and went to bed with "Call to Quarters," followed by "Taps." Before breakfast, members stood at attention saluting and raising the flag with "To the Colors," and they assembled in the evening for the flag lowering with the bugler playing "Retreat." This became a tradition at band camps through all the years.

Each weekly camp session included meals, sleeping quarters, camp privileges, private lessons, and supervised band rehearsals. The camp was musical, educational, recreational, and a healthy outdoor existence. The entire camp consisted of 125 tents with two boys to a tent and was acclaimed one of the most complete tented cities for boys' camp activities in eastern Ohio and western Pennsylvania.

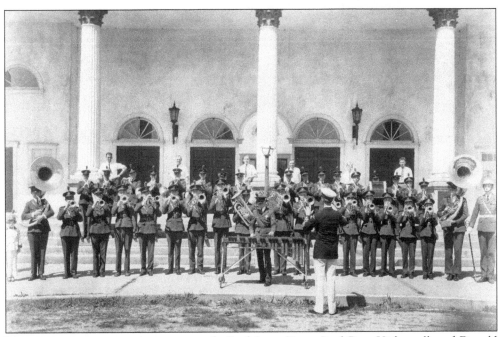

Music instruction at camp was top-notch. Prof. Lynn Dana, Prof. Ross Hickernell, and Donald Hurrelbrink provided private and group instruction in theory, harmony, piano, and on all band instruments, while Carlos Bradley taught the military band drill. Daily rehearsals and formal concerts were conducted in the Temple of Music, the largest building of its type in the Midwest. The band's male chorus and German band also entertained audiences. (Courtesy of W.W. Wilt.)

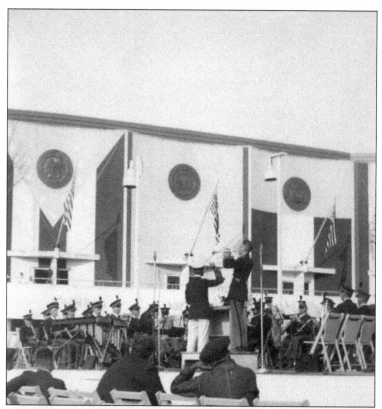

As part of a 12-day tour, the band appeared as guest artists at the 1933 Chicago International Exposition. The four-day engagement included daily concerts at the Chrysler Building, Floating Theater, Court of States, and Century of Progress and in nearby cities. Robert Anthony, cornet soloist, performed "Sounds from the Hudson." Other soloists included George Garstick, trombone; William Joseph, xylophone; and J. Allen Frye, vocalist. (Courtesy of Kaufmann Fabity.)

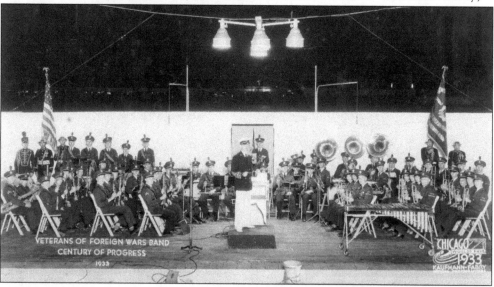

Marches, xylophone features, and light favorites filled the air at the 1933 International Exposition concerts along with well-known selections such as *Slavonic Rhapsody*, the *William Tell Overture*, *The Blue Danube* waltz, and the *Poet and Peasant Overture*. The Expo Committee reported: "We have had more favorable comments in regard to the playing of this band than any other similar organization." The band was now sponsored by Trumbull VFW Post 2662. (Courtesy of Kaufmann Fabity.)

In August 1933, the 70-member band won its third VFW National Championship in Milwaukee. As guests of the 33rd National VFW Encampment, the band led the parade and then returned to the Chicago Exposition for a VFW Day performance. Before a crowd of 5,000 veterans and townspeople, two concerts were also played at the VFW National Home in Eaton Rapids, Michigan. (Courtesy of John Taylor.)

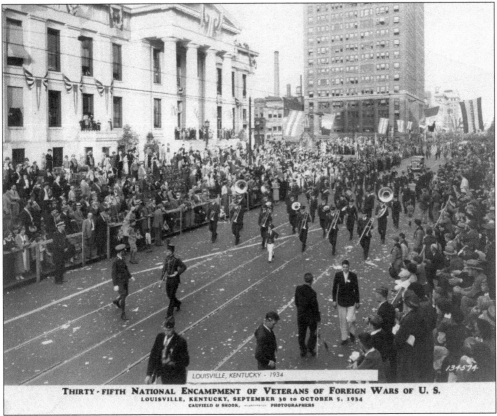

The band successfully defended its VFW National Championship in Louisville in 1934 and was appointed the official convention band. Competition score sheets were divided into three categories: inspection and general appearance, 10 points; playing ability, 70 points; and general marching ability, 20 points. Marching was military style, with a strict drum cadence of 128 to 132 beats per minute. (Courtesy of Cauffield & Shook Photographers.)

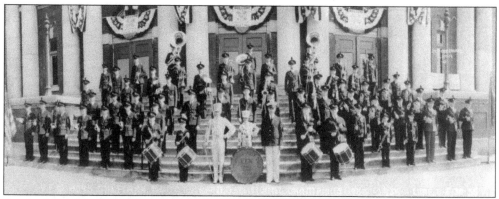

At the 1935 State VFW Encampment in Lima, the band wowed judges and the audience by performing the last section of the *William Tell Overture* by memory. One judge stated that this was "remarkable for any musical organization, especially so for boys under 20." The 70 members came primarily from within a 100-mile radius of Warren. Bob Anthony took the bus from Cleveland every Sunday for rehearsals, and Harlon Fizer hitchhiked from Zelionople. (Courtesy of Zimmerman.)

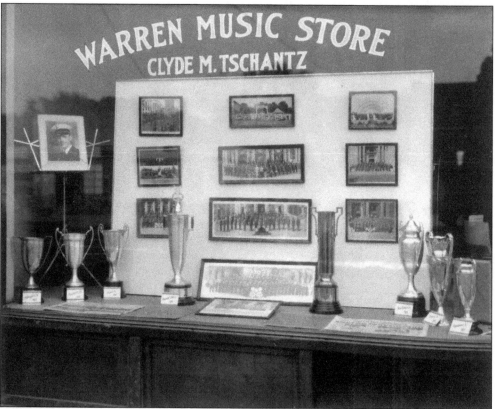

Warren's music stores provided strong support for the musical arts. This display features photographs and trophies won from 1927 to 1936. In 1937, Warren had five concert bands, a drum corps, an accordion band, a grotto band, and a high school band. With their military-style marching and their excellence in music ability, members of the VFW Boys Band often received full scholarships to military and university music schools.

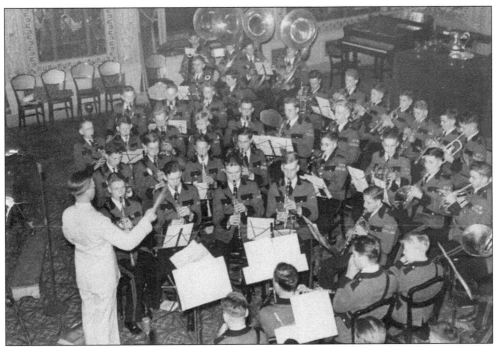

Maj. Gen. Adelbert Cronkhite, war commander of the 80th Army Division, adopted the band as one of his favorite organizations. The band performed for him on numerous occasions, including a four-day engagement at the 15th Annual National Army Reunion at Conneaut Lake Park in 1934 and at the 17th Annual National Army Reunion in Pittsburgh. Among many festivities, daily concerts were performed by the VFW Boys Band with the director appearing in what came to be known as his signature white uniform. One of the highlights in Pittsburgh was the parade led by the color guard carrying the flags of the 80th Division. (Both, courtesy of D.A. Feigley.)

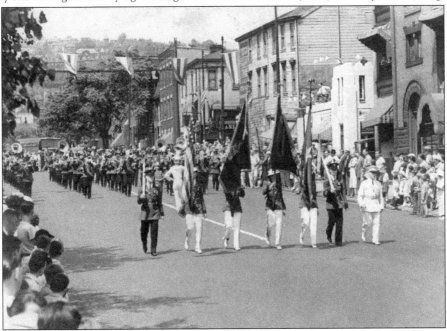

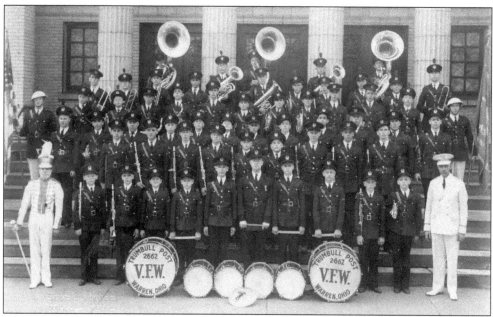

In the early days, the boys competed against senior and professional bands. In Denver in 1936, the Chicago Elevators' and Starters' Professional Band won by three-tenths of a point. After winning the state VFW title in Toledo in 1937, Warren again placed second to the Chicago band in Buffalo but regained the VFW National Championship at the 1938 National VFW Encampment in Columbus, Ohio, beating this same professional band by four-tenths of a point. (Courtesy of Frank Studio.)

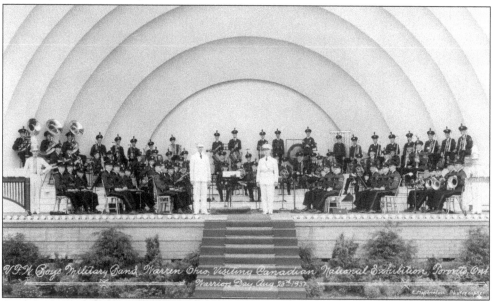

At the 1937 Canadian National Exhibition in Toronto, the band was honored as the only non-adult band invited to perform. Warren served as co-artist with the US Navy Band for the Warriors Day concert, broadcast on a national hookup from the Exhibition Band Shell. Celebrating the VFW in 1939, the band paraded along with 60 musical units, color guards, and over 5,000 veterans at the New York World's Fair. (Courtesy of E. Mackintosh.)

Two

1940s–1950s

There were changes during these years, with sponsorship and rehearsals moving to Girard and back to Warren again; majorettes in 1940 and girls as playing members in 1942; new uniforms in 1946 and 1954; and band camp locations changing from Kiondashawa to Camp Crag, Lakeside, and Chautauqua. Many concerts supported war efforts, with the band featured on *Hello, America* broadcasts. December 7, 1941, was the beginning of Squire's tradition of playing "The Star-Spangled Banner" at all rehearsals and performances.

The band participated in many VFW Million Dollar Pageant of Drums and felt indescribable happiness on hearing "in first place and VFW National Champions." The band won 13 national championship titles along with many VFW State and National Championships in twirling, strutting, and drumming. The 1953 VFW National Championship in Milwaukee was memorable for Squire, coming 20 years after his first championship there. Other competition memories include participating in Paul Lavalle's broadcast of Bands of America in New York; racing north from Miami to stay six hours ahead of Hurricane Harry; 116-degree heat in Dallas and marching in the 106-degree VFW National Encampment Parade at night; gathering on hotel porches for battles of music in Atlantic City; and displaying flags and banners from national conventions. This era was highlighted by a parade in Youngstown in which Gen. George Marshall marched with the band; sponsoring the US Navy Band and "The President's Own" Marine Band in concert; receiving standing ovations and playing multiple encores at Chautauqua and Lakeside; performing at the 1948 World Series; receiving a standing ovation from the largest crowd (at that time) in baseball history at a 1954 Cleveland Indians–New York Yankees game; performing at Derby Downs in Akron for National Soap Box Derby events; playing concerts locally and at Buhl Park; beginning the first of many annual concerts at Packard Music Hall; an Independence Day ceremony at Chautauqua with Gen. Dwight D. Eisenhower; and remembering the many band members who served their country.

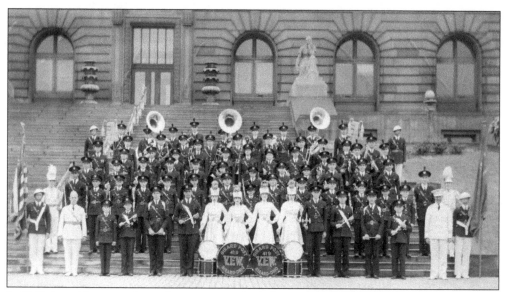

In 1940, four girls were welcomed as majorettes. In dashing white costumes, they performed twirling exhibitions as part of concert programs and added a new sparkle to the band in parades. At this time, due to economic conditions in Warren, the sponsorship of the band moved to Girard VFW Post 419. With girls, the name was changed to the VFW Band.

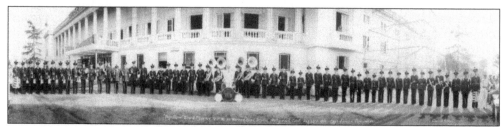

Part of the band is shown at the Warner Bros. Studios, where the group was housed while in Los Angeles. The band played a memorial concert in the Hollywood Bowl and opened the 1940 VFW National Encampment with "The Star-Spangled Banner" at the Philharmonic Auditorium. After winning its seventh VFW National Championship, the band traveled by train, performing and sightseeing at the Golden Gate Exposition, the Grand Canyon, Salt Lake City, Colorado Springs, and Chicago. (Courtesy of Charles Z. Bailey.)

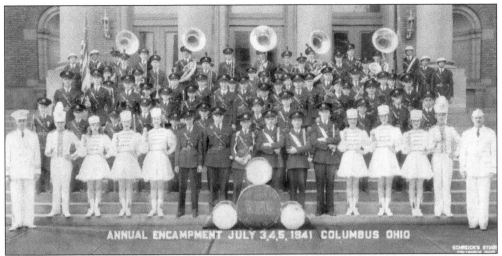

The 1941 State VFW Encampment in Columbus saw the band score 93.76, the highest of any group in the previous 14 years. The band's eighth VFW National Championship was won in Philadelphia with concerts at Independence Hall and the naval hospital. The band was complimented as the only organization completing inspection in the sweltering heat with all members standing. As VFW National Champions, the band led the procession in all parades. (Courtesy of Schreick's Studio.)

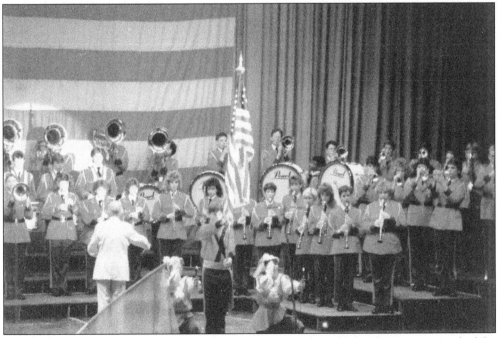

The band was rehearsing on Sunday, December 7, 1941, when the somber news arrived of the Japanese bombing of Pearl Harbor. Squire immediately had the band stand, called for a drum roll, and conducted "The Star-Spangled Banner." The boys were then sent home to their families. This began the tradition of playing the national anthem at the end of every rehearsal and concert performance, as shown in this 1980s photograph.

During the war years, the band played many patriotic and war fundraising events. *Victory Is Our Business* featured the band as Packard Electric received Army-Navy "E" Awards. Joint concerts with various musical groups featured service marches and familiar songs like "White Cliffs of Dover," "Remember Pearl Harbor," "Victor Herbert Favorites," "America," "God Bless America," "Stars and Stripes Forever," and "The Star-Spangled Banner." The band was featured in the weekly *Hello, America* radio broadcasts, heard across the country and over shortwave radio by troops serving abroad. These one-hour shows of varied entertainment were broadcast from Washington, New York, Hollywood, and Youngstown. The band's structure, activity, and performances were all affected by World War II conditions and morale. Philo Schontz became the new band manager when Colonel Friend was recalled to active duty. With gas rationing, he made two round-trips on Sundays in an old bus called B19½ so members could attend rehearsals. Others hitchhiked. (Courtesy of Packard Electric.)

Shown in long gowns, girls were admitted in 1942 as playing members. Many older boys had left to serve their country, but the band remained strong in numbers. The oldest members were now only 17. Rehearsals were once a week, usually four hours on Sunday afternoons. Traveling and concerts were mainly at the local level. Selections performed were patriotic and uplifting. (Courtesy of Harold Byland.)

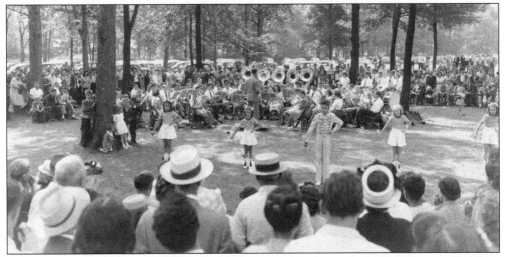

More majorettes joined in 1946. These new girls were referred to as the little majorettes. Hundreds filled Packard Park to hear VFW Band concerts. Featured twirling to a rousing march are, from left to right, Sally Cole, Donna Hurrelbrink, junior drum major Tommy Zedeker, Joyce Tupper, and Delores Evans. National competitions resumed in 1945 in Cleveland, where the band won its ninth VFW National Championship. (Courtesy of *Tribune Chronicle*.)

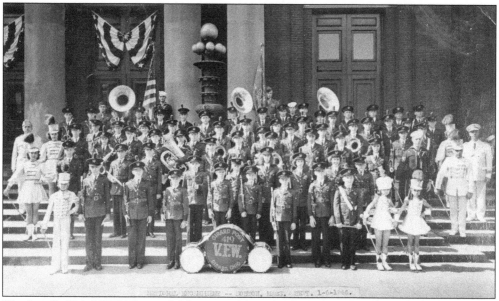

The band's 10th VFW National Championship was won in 1946 in Boston, with $750 prize money. Inspection was at Hatch Shell on the Charles River, concert competition at the Boston Conservatory of Music, and marching competition at Harvard Stadium, with an estimated crowd of 45,000. The convention parade through downtown Boston lasted six hours with 25,000 marchers and over a million spectators. (Courtesy of VFW Encampment.)

Band camp was discontinued during the war years. The old tradition of hard work, daily concert rehearsals, and marching drills in preparation for competition was revived in 1947 at Camp Kiondashawa in Transfer, Pennsylvania. There were plenty of rehearsals but also time for swimming, horseshoes, table tennis, and baseball. Shown here is the chow line by the dining hall.

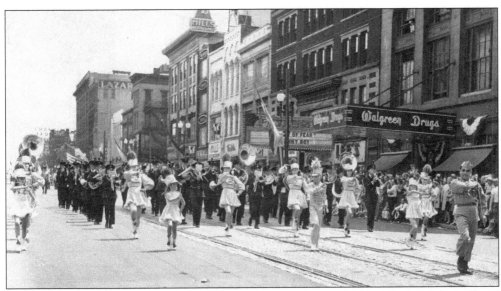

At the 1947 VFW State Encampment in Columbus, Tony Fortunato led the band down Broad Street followed by the junior drum major, little majorettes, and big majorettes. Throughout all VFW and American Legion state competitions it entered, the band never scored lower than first place. State and national competitions allowed many outstanding members to compete individually in twirling, strutting, and drumming, garnering many top awards. (Courtesy of William H. Shupe.)

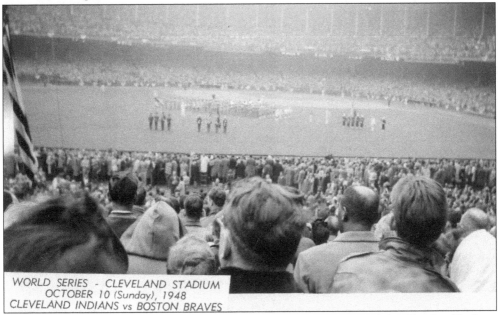

WORLD SERIES - CLEVELAND STADIUM
OCTOBER 10 (Sunday), 1948
CLEVELAND INDIANS vs BOSTON BRAVES

The fifth game of the 1948 World Series between the Boston Braves and the Cleveland Indians was played before 86,288 spectators at Municipal Stadium in Cleveland. As guests of the Cleveland baseball club, the band entertained the crowd before and after the game while Tommy Zedeker delighted them with his uncanny twirling accuracy. The spectators were familiar with the band's accomplishments, and great rounds of applause greeted it. The band's 12th VFW National Championship was also won that summer in Cleveland. (Courtesy of Bill ?)

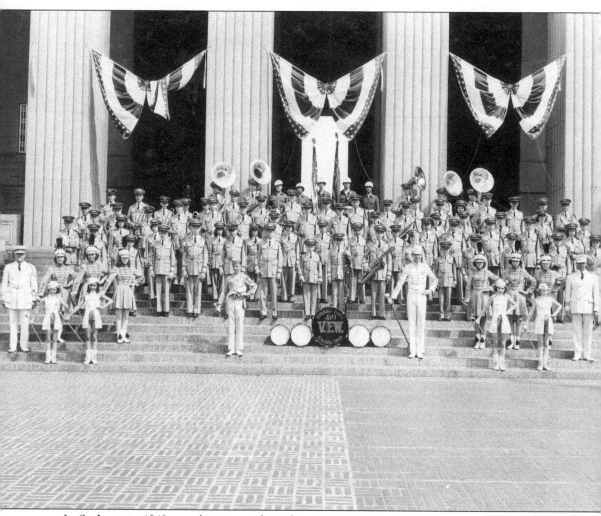

In St. Louis in 1948, members were adorned in new pearl-gray uniforms trimmed with narrow black beading around the collar, pockets, and belt. Trousers had two narrow seams of black. The entire ensemble was set off with highly polished VFW insignia buttons. Majorettes had black scrollwork set off with shiny round buttons. In August, the band traveled to St. Louis for the VFW National Encampment. Competition was stiff. Bands from Milwaukee and Wilkensburg were there to dethrone them. Then the announcement came, "In first place, VFW National Champions, the VFW Band from Post 419 in Girard, Ohio." On July 5, 1948, the band opened the 75th season in Chautauqua, New York, at the renowned international educational institution and summer resort. The band performed two concerts for 5,500 attendees prior to guest speaker Gen. Dwight D. Eisenhower. (Courtesy of Marvin-Anderson Studios.)

Band camp moved to its new location in 1949 at Camp Crag in Brunswick, Ohio. The Quonset hut was both a dining and rehearsal facility. Members were intense in their concert music and marching preparation for the upcoming competition in Miami. Hiking across the swinging bridge, swimming, marching squad competitions, and baseball games became highlights when free time was available. (Courtesy of Camp Crag.)

Daily cabin inspections were part of camp life. After breakfast, members stood at attention as older members looked everything over in the cabin. A rumpled bed, a trunk not closed tight, or grass or dirt by the bed could easily mean kitchen patrol or some other duty the next day. Some cabins were meticulous, while others flunked on a regular basis.

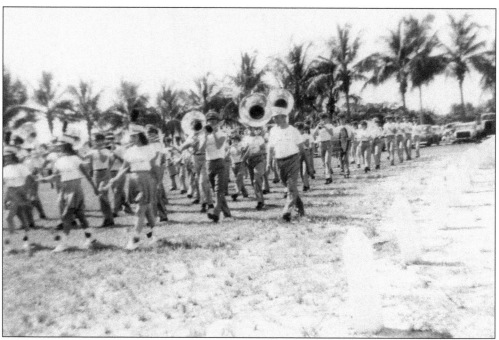

The band traveled to the VFW National Encampment in Miami in 1949, winning its 13th VFW National Championship. Due to the extreme heat of late August, inspection was held indoors. Concert competition was at Biscayne Park before an audience of 12,000 with the band requested to play an encore. Marching competition was in the Orange Bowl. In a special concert performance during the convention, the band played alongside the US Marine Band, receiving a tremendous ovation from the audience and the Marine Band itself. Following a parade rehearsal and the annual convention parade, the weather changed swiftly. Hurricane Harry had changed directions and increased in intensity to 110 miles per hour. The band loaded quickly into three buses and headed up the coastal highway, staying just six hours ahead of landfall. The *Miami Daily News* featured front-page pictures of the surf splashing up the sides of the buses.

Represented here is the emblem worn on members' casual band jackets at this time. Emblems changed over the years from this to a top hat and cane, the shape of Ohio, and finally to an embroidered version.

The 51st Annual VFW Encampment was held in Chicago in 1950. Time was always made available to enjoy the sights and landmarks of the cities the band visited. In Chicago, a highlight was the band's girls' chorus entertaining Tommy Bartlett and the radio audience on the NBC show *Welcome Travelers*.

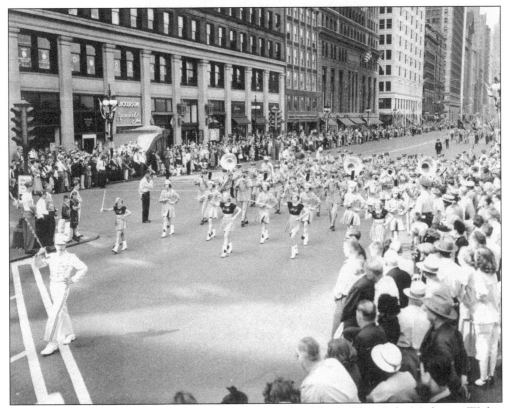

In Chicago, competitions were held at Grant Park and Soldier Field on Lake Michigan. With a score of 92.5, highest of all musical units, the band won its 14th VFW National Championship, being the only band asked to perform at the Pageant of Drums. The four-hour convention parade was at that time the biggest in VFW history, with over 25,000 marchers and 100 musical units.

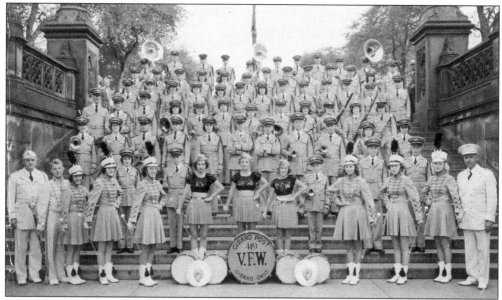

The concert competition at the 1951 National VFW Encampment in New York City was in Central Park with an evening parade up Broadway and down Fifth Avenue led by the VFW Band. The Pageant of Drums was held before 22,000 spectators at Jersey City's Roosevelt Stadium. When winners were announced, drum majors accepted trophies, and the band learned it had swept all phases of the competition for its 15th VFW National Championship. (Courtesy of Empire Photographers, Inc.)

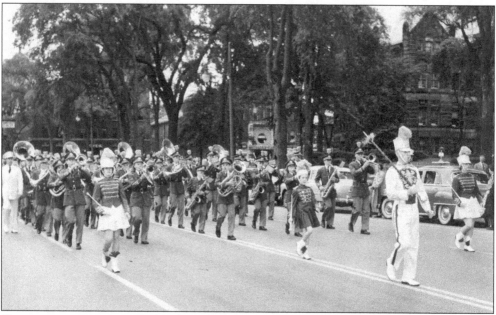

On numerous occasions, the band paraded down Market Street in Warren past Court House Park. There were parades for Loyalty Day, Memorial Day, Independence Day, Armistice Day, Halloween, Christmas, special events, and various local festivals and festivities. Rain, shine, or snow, the parade usually went on. In this photograph, drum major Dan Fisher leads the way. (Courtesy of *Tribune Chronicle*.)

Chautauqua, New York, was the site of band camp for three years beginning in 1951, then camp moved to Lakeside, Ohio, for two years before returning to Camp Crag. Both Lakeside's Hoover Auditorium and Chautauqua's amphitheater had outstanding acoustics for rehearsals, but the band had to move down the road for marching rehearsals. Camp baseball games centered around a fun-spirited rivalry between Freeman's Angels and Raybuck's Devils.

SOUSA MEMORIAL CONCERT

7-5-51

Tonight at 8:30 in the Amphitheater

By

The VFW Military Band of Girard, Ohio

DONALD W. HURRELBRINK, Director

1—Semper Fidelis March
2—"The Black Man" (from "The Dwellers of the Western World")
3—High School Cadets March
4—"The Kaffir on the Karoo" (from "The Tales of a Traveler")
5—Washington Post March
6—The Grand Promenade at the White House (from "The Tales of a Traveler")
7—The Belle of Chicago March
8—"By the Light of the Polar Star" (from "Looking Upward" Suite)
9—The Gladiator March
10—"Beneath the Southern Cross" (from "Looking Upward" Suite)
11—The Occidental March
12—The Crusader March
13—The Thunderer March
14—The Corcoran Cadets March
15—The Stars and Stripes Forever March
 The Star Spangled Banner

The band opened the 78th season at the Chautauqua Amphitheater with four concerts. Several thousand vacationers from all over the world were in attendance. One concert featured only the works of John Philip Sousa, including many of his well-known marches and some of his lesser-known orchestral selections: "Looking Upward," "Tales of a Traveler," and "Dwellers of the Western World." (Courtesy of Chautauqua.)

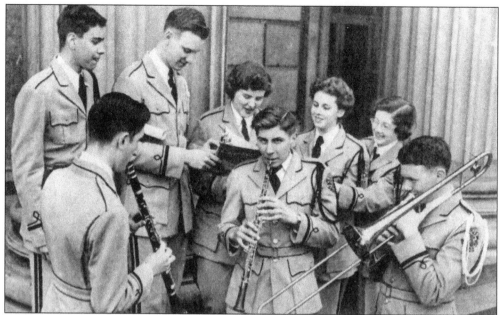

In 1952, for its 25th anniversary, the band sponsored the US Navy Band for two concerts at Stambaugh Auditorium. Eight band members were chosen to perform with the Navy Band. From left to right are (first row) Bill James, Tom Dragus, and Howard Johnson; (second row) Bob Hummer, Ron Schinck, Rose Marie Macek, Esther Kimmel, and Mary Lou Buchwalter. During the matinee, the band's drum majors and majorettes gave an exhibition. (Courtesy of the *Vindicator*.)

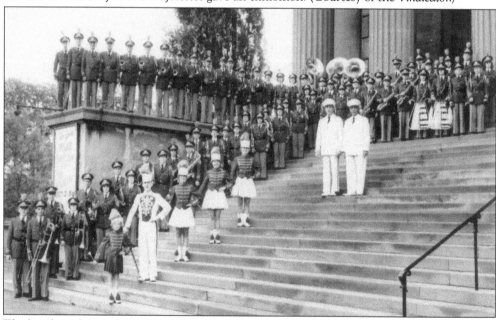

The band was featured in many concert performances at Stambaugh Auditorium in Youngstown over the years. During the VFW parade in Milwaukee in 1953, it drizzled, rained, and then came the cloudburst. The pearl-gray wool uniforms shrank beyond repair. This photograph on the Stambaugh steps shows the new uniforms. In 1954, the band sponsored two concerts of "The President's Own" US Marine Corps Band here. (Courtesy of Harold D. Byland.)

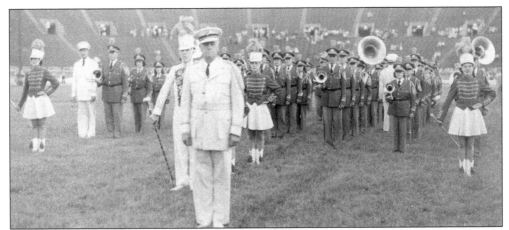

At the 1954 VFW National Encampment in Philadelphia, the band showed off its new uniforms: red coats with gold braids, black belts, gold VFW insignia buttons, gold plumes, and French blue pants. Warren was so thrilled with the band returning to VFW Post 1090 that $10,500 was raised for new uniforms, with Mayor William Burbank and local businessmen heading up the fundraising. In front is band manager Philo Schontz.

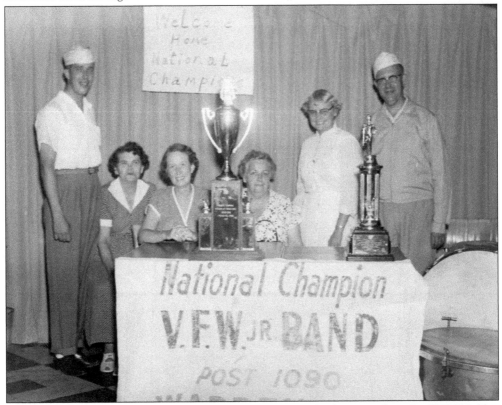

With a score of 92.5, the band won its 17th VFW National Championship, the VFW Hidden Judges Award, and the VFW's Most Colorful Unit trophy for the most outstanding unit in the seven-hour convention parade. Showing off the trophies at VFW Post 1090 in Warren are, from left to right, Post 1090 band manager Walter Fredrick, band mother Mary Freeman, Gertrude Hurrelbrink, band mother Ethel Raybuck, band nurse Gladys Wehr, and Squire.

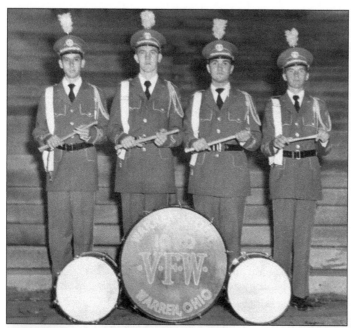

In Philadelphia, the band's drum quartet, called the Black Cats, entered the national drum competition. From left to right are Frank Logar, John Tudhope, Nick Ceroli, and Mickey Kaiser. Playing on old black drums, the Black Cats won the VFW Drum Quartet National Championship, beating the best of the drum corps percussion quartets.

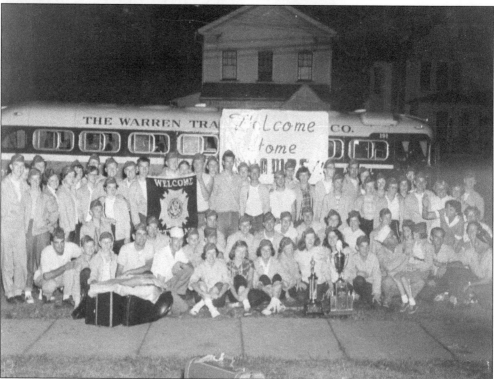

On the band's return from Philadelphia, a police escort led the buses to VFW Post 1090 in Warren, where a cheering crowd of parents, post members, and townspeople greeted the band and loudly applauded its successes in Philadelphia. Cameras flashed as newspapers ran photographs and articles praising the band on representing the entire area in such a great way. (Courtesy of *Tribune Chronicle*.)

The WARREN JUNIOR MILITARY BAND, Inc.

P. O. BOX 746 WARREN, OHIO

A youth organization established 1927 to promote educational,
physical, moral and social development through music.

_____ _____
Director President

The year 1957 was one of reorganization. The band would be sponsored by the Warren Chamber of Commerce and would be self-financed. Warren mayor William Burbank outlined three main purposes. The band was to be a nonprofit organization. The band was to provide music and entertainment at civic functions without being in competition with professional groups. The band was to be available to all organizations for sponsorship in individual competitions. With the band incorporating in March as a nonprofit musical group for youngsters between the ages of 12 and 21, a new insignia was needed to display on the bass drum. Mayor Burbank suggested an emblem that could be used as the official seal of the city. It was decided the emblem should depict Warren as an industrial, cultural, and religious center. The emblem was designed by band parent Robert Wellington and approved by Warren City Council on July 29. When the band traveled and performed, the city's new seal would be seen by thousands.

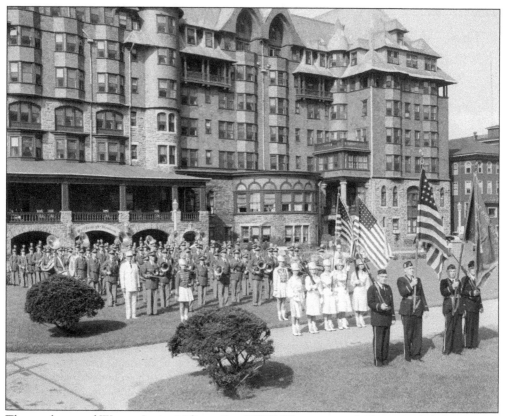

The newly named Warren Junior Military Band (WJMB) represented Clarence Hyde Post 278 in Atlantic City in 1957. Eighty members competed in the 39th Annual American Legion Convention and were successful in attaining their 18th national championship. It was a tough competition, with the Lake Band of Milwaukee in second place. The 12-hour-long convention parade on the boardwalk featured 60,000 marchers. (Courtesy of Fred Hess and Son.)

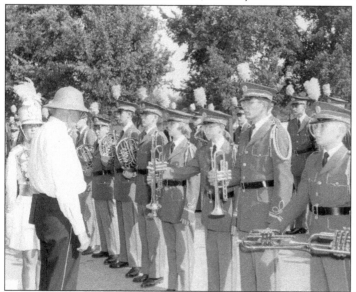

A tremendous amount of care went into inspection preparation. A speck of lint, a button not properly lined up, fray on the braid, a tie not properly aligned, heels not at a 45-degree angle—such items could mean a 10th of a point deduction per item. Instruments had to be highly polished with no smudges. As the judge approached, members snapped to attention, presenting themselves and their instruments for inspection. (Courtesy of PICS Chicago.)

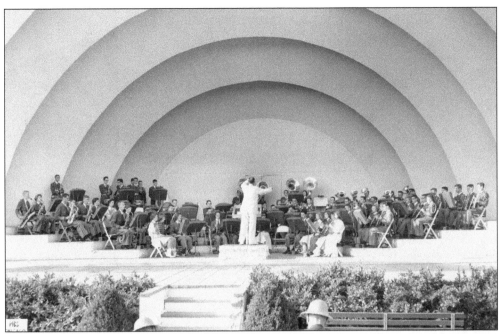

Concert competition in the Grant Park Band Shell was carefully scrutinized by three judges following every note and every musical marking on the conductor's score. They checked instrumentation, watched the conductor's movements, and listened intently to the band's intonation and interpretation of the musical selections. The band represented American Legion Post 278 in the competition for the second time in 1958. With 12 bands competing for the title, drum major Donna Hurrelbrink led the band through its marching paces. When inspection, marching, and concert competitions were over, the band had won its 19th national championship title. Along with the image at the bottom of page 40, these two Chicago photographs show a complete competition: inspection, concert, and marching. (Both, courtesy of PICS Chicago.)

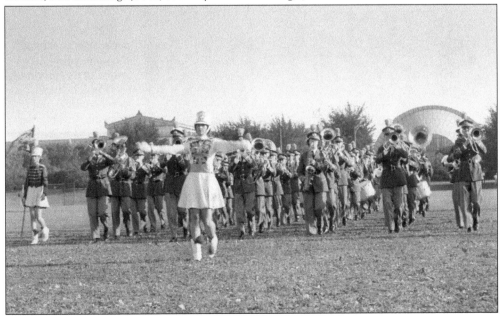

During the 1950s, the band played many encore performances at the marvelous Lakeside Hoover Auditorium. One year, the percussionists forgot the blank pistol to simulate cannons going off at the end of the *1812 Overture*, so they improvised by throwing cherry bombs into a trash can. It was a great sound effect, but the can caught fire. When the number ended, all the band members could hear was the fire extinguisher. Squire was not happy.

A Minneapolis newspaper photograph shows members prepping for inspection in 1959. The band won marching and maneuvering, but the overall championship went to the Racine Elks Youth Band, edging out Warren by .12 points. There is sadness in placing second after all the many hours of practice, but it brings a determination to win the title back the next year. (Courtesy of Minneapolis Star and Tribune Co.)

Three

1960s

The 1960s were a first for band camps in Toronto, Ohio; recording annual concerts at Packard Music Hall; being chosen as the official band for the GOP state convention; appearing in Kenley Players finales of *Music Man* and *How Now, Dow Jones*; and marching in many religious parades for Mount Carmel Church in Niles. During the 1960s, the band welcomed alumni at Squire's surprise 30th anniversary; participated in American Legion and state VFW encampments; won its 20th VFW National Championship and numerous Most Colorful Unit parade trophies; played for thousands in Chautauqua for Independence Day concerts; and enjoyed enthusiastic audiences at Lakeside concerts. Squire was honored with city, state, and national awards. Locally, the band performed in hundreds of parades, concerts, dedications, celebrations, and festivities; worked many tag days as fundraisers; played for the presidential campaigns of Nixon, Lodge, Goldwater, and Kennedy; provided music for numerous dignitaries visiting Warren and surrounding areas; began many years of band night performances; held a memorial service for Pres. John F. Kennedy; and played a memorial concert for Gertrude Hurrelbrink. In addition to competitions, the band performed at the New York World's Fair and in Montreal at Expo '67 at the request of the US State Department. At the request of Montreal's mayor, the band returned to play at Man and His World. In its first European appearance, the band represented American youth, performing for enthusiastic audiences, highlighted by concerts in Rome and Lucerne until dark. It also joined the celebration in the tiny German town of Holzkïrchen.

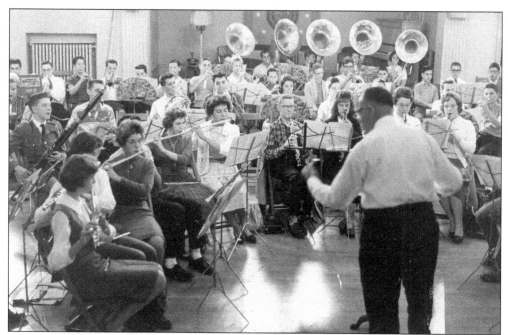

Rehearsals were held in many locations throughout the years, including Warren, Girard, Howland, Niles, Vienna, and Youngstown. In the late 1950s and the 1960s, concert rehearsals were held at American Legion Post 278 in Warren. Rehearsals were Sunday afternoons and Wednesday evenings except for holidays. Band camps were generally two weeks, and tours were two to three weeks each summer. (Courtesy of *Tribune Chronicle*.)

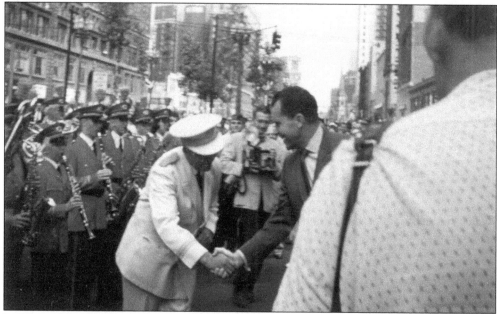

In Detroit, Vice President Nixon was on the agenda for the VFW National Encampment. WJMB was accorded the honor of greeting him upon his arrival. He stopped his motorcade and got out to chat with Squire for 10 minutes, praising the band and remembering it from an earlier visit to Warren. In Detroit that year, the band won its 20th VFW National Championship.

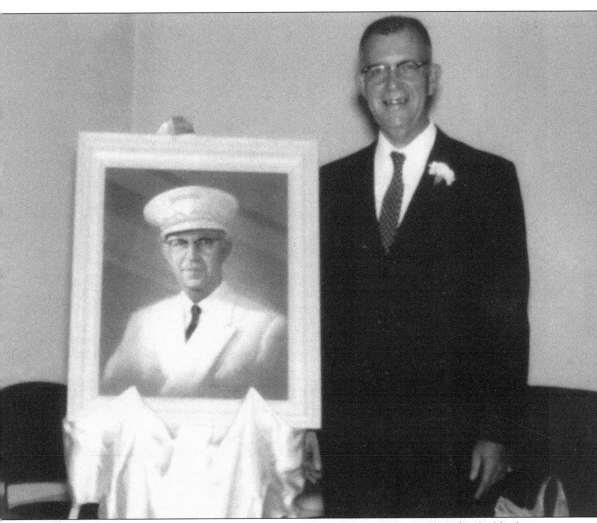

It was a normal Sunday afternoon rehearsal in October 1960, or so Squire thought. Suddenly, a drum roll, "Colonel Bogey March," was played, the doors of the American Legion hall swung open, and over 500 alumni, parents, friends, and guests entered, including several members from the first band under Squire's direction in 1930. Taken completely by surprise, Squire just smiled. City officials, local mayors, alumni, former director Raymond Dehnbostel, and others had all gathered to honor Squire. After many high praises, band member Judy Crone unveiled an oil portrait of Squire in recognition of 30 years of service and the splendid record of achievement. Squire was also honored at the 61st VFW National Encampment in Detroit. Before 40,000 spectators at the Pageant of Drums, Squire was presented the first National VFW Commander's Citation in recognition of his skill and "consistent dedication to the principles of friendly cooperation, hard work, and perfection inspiring thousands over 30 years."

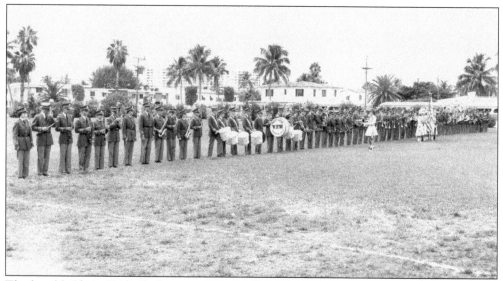

The band held a wide lead after inspection and concert competition in Miami in 1961. The marching performance began with the company front at Flamingo Park. Cadence had to be 128 to 132 beats per minute, but the tempo increased slightly, and the band exited the field a few seconds too early, collecting an automatic penalty. Even with WJMB's fantastic concert score, the penalty allowed the band from Racine, Wisconsin, to take first place. (Courtesy of Kenneth Kipnis.)

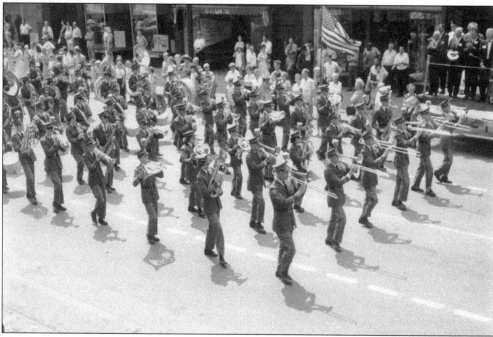

The band received numerous requests for parades, concerts, festivals, dedications, memorial services, patriotic festivities, and other events. The band is seen here marching down Main Street in Ashtabula, Ohio. It always made a strong impression in parades. At the 1962 VFW National Encampment in Minneapolis, WJMB was crowned the VFW's Most Colorful Unit, beating over 100 other units in the VFW parade. (Courtesy of Russell Flint.)

The color guard became an outstanding patriotic feature of the band. There was great pride in carrying the American flag. Proper flag protocol and etiquette were followed, with the American flag always guarded. A flag signifying the band as national champion was also carried. Pictured from left to right in 1963 are Peggy Phillips, Patricia Sherman, Betty Cooper, Kae Evans, and Sara Mueller. (Courtesy of *Tribune Chronicle*.)

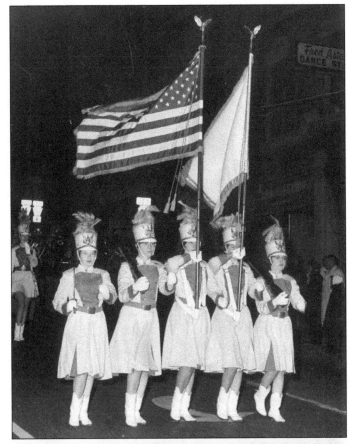

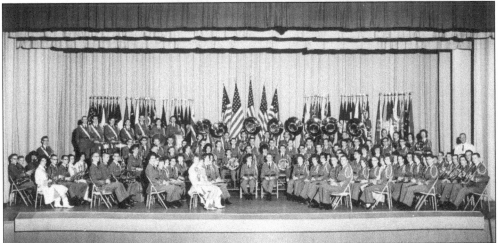

In 1963, Packard Music Hall's stage was lined with Dr. Charles Anderson's historical flag collection. The 106 members performed "American Overture for Band," the *1812 Overture*, *Oberon*, selections from *West Side Story*, *Victory at Sea*, and other selections along with soloists and ensembles. The finale of annual concerts featured alumni joining the band for "Stars and Stripes Forever." Audience members commented, "They're national champs, but they perform like world champions." (Courtesy of *Tribune Chronicle*.)

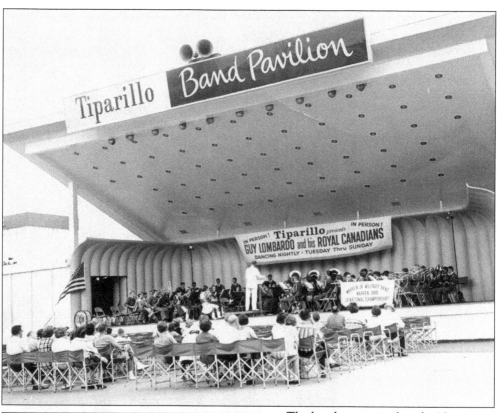

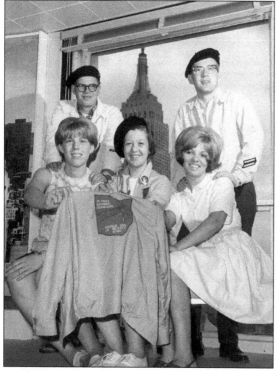

The band was invited to the New York World's Fair in both 1964 and 1965. Performances included parades, concerts, field show music exhibitions, and special ceremonies for the National American Legion. With the Unisphere as its theme, the band performed selections from Spain, Italy, Germany, Czecholovakia, and the American West. Members enjoyed fair exhibits, Ellis Island, and Radio City Music Hall. (Courtesy of Fred Greene.)

The city tour featured a visit to the Empire State Building and the 31st floor of the New York Life Building. Posing with one of the band jackets worn by all members are, from left to right, (first row) ? Yourst, Florence Comer, and Rita Sartorio; (second row) Al Smith and Don Reed. When the photograph was published, the byline in a local newspaper stated that members appeared to be "on top of the world."

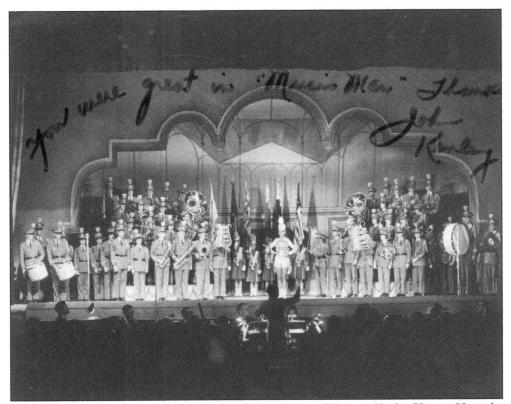

What's the best way to end a performance of *Music Man* at Warren's Kenley Players? Have the Warren Junior Military Band come down the aisle with drum major Gig Young leading the way. Let members march up the stairs, fill the stage of Packard Music Hall, and end the show with tremendous excitement and showmanship. For nine performances in 1965, John Kenley created this masterful finale. (Courtesy of *Tribune Chronicle*.)

A quilt with hundreds of alumni names embroidered on it was presented to Squire and his wife in 1965 with many heartfelt thanks for both their efforts over all the years. Everyone enjoyed the camaraderie of the many alumni and friends who turned out for the party. To members, Squire's wife was affectionately called "Aunt Gert." (Courtesy of *Tribune Chronicle*.)

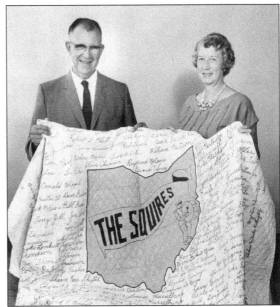

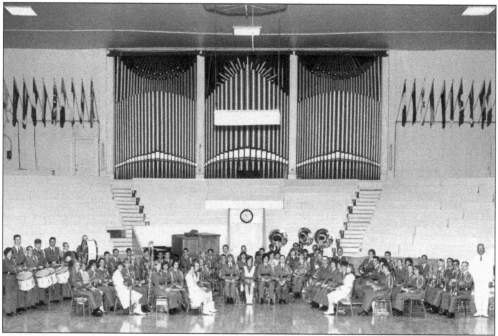

The band was featured in two concerts at the 1966 Independence Day celebration in the amphitheater at the Chautauqua Institution in Chautauqua, New York. Selections for the evening performance included *Victory at Sea*, *Ballet Egyptien*, "The Blue and the Gray," *The Italian in Algiers*, patriotic American favorites, marches, and soloists. The crowd of 6,000 gave the band standing ovations for both concerts. (Courtesy of Charles Nash Studio.)

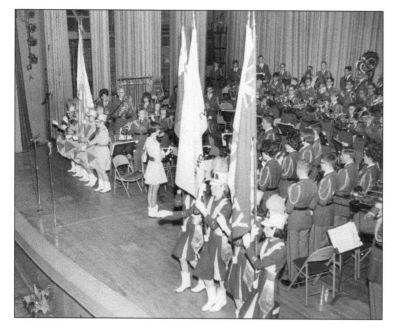

The 1966 concert celebrated Squire's 35th year with the band. Music featured two outstanding soloists playing among the vast number of trophies displayed on the sides of the stage. The concert program was filled with pictures, newspaper headlines, interesting memories, and highlights through the years. A flag line was added that year in addition to the color guard. (Courtesy of Perich Studio.)

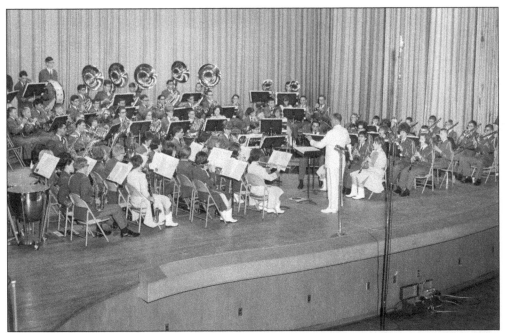

The eighth annual concert, entitled One World Through Music, featured the *Roman Carnival Overture*, the *Hebrides Suite*, selections from *Man of La Mancha*, the *Cinderella Overture*, "On the Trail," and "America the Beautiful." A crowd favorite was the lively "Red's White and Blue," a march written by Red Skelton. Annual concerts were always recorded, with the 1960 performance recorded by Fleetwood Records distributed across the country. (Courtesy of Perich Studio.)

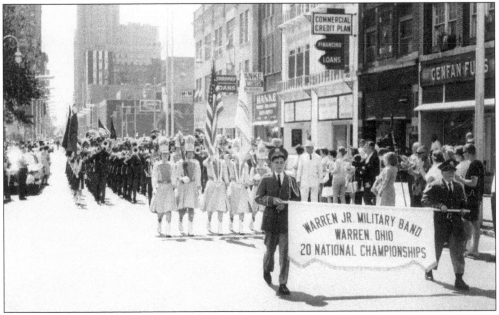

Familiar locations for the state VFW encampments and American Legion conventions were Cincinnati, Cleveland, Columbus, Dayton, and Toledo. Marching down Broad Street in Columbus in 1967, the band once again won the VFW's Most Colorful Unit trophy as well as first place in the junior band competition. The banner always preceded the color guard to announce the band.

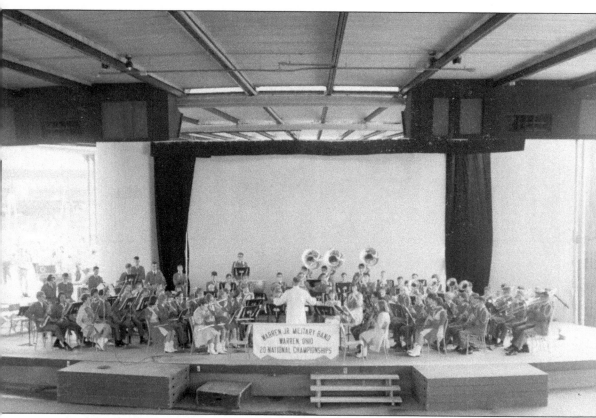

It was a great honor for the band to be invited to Expo '67 by the US State Department "to musically represent to peoples of other lands the great American heritage and democratic way of life." Man and His World was the unifying theme of Expo '67, held in Montreal, Canada. What better way to present cooperation between men of all nations than through the common language of music? Concerts featured a varied program of international flavor and were so well received that all time limits were waived. Shouts of "Bravo! Bravo! More! More!" filled the air, and members signed hundreds of autographs after the performances. The band was so well received that the mayor of Montreal invited the group to return in 1968 for an additional eight performances. The band was proud to carry both the Canadian and American flags and to perform both national anthems, "O Canada" and "The Star-Spangled Banner." Performances were also played in Quebec City and on Parliament Hill in Ottawa.

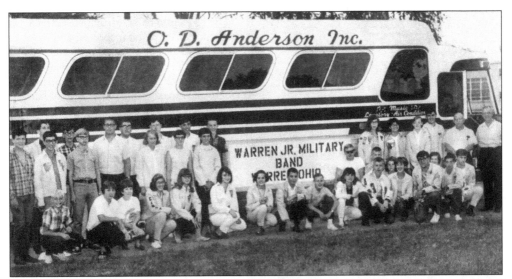

No one would ever be able to accurately calculate the number of miles traveled, the number of rehearsals held, the number of parades marched, the number of concerts played, the number of competitions, or the number of field shows presented over 83 years. The anticipation and excitement of boarding a train or bus for a major competition, concert, or tour was indescribable. (Courtesy of *Tribune Chronicle*.)

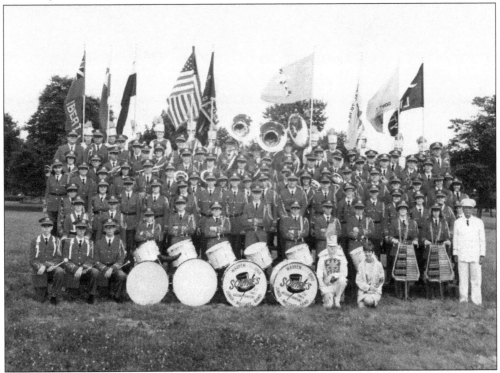

Being in high demand for Fourth of July celebrations, two to three parades, concerts, and field shows was the norm. In Columbiana, a concert preceded the 1968 field show performance prior to the fireworks display. The memorial flag, fourth from right, was carried in tribute to Gertrude Hurrelbrink, who had passed earlier that year. (Courtesy of Firestone Photographs.)

The French horn and trumpet sections rehearse after being inspected and evaluated for condition of uniform. At times, a Sunday dress rehearsal was held to check length of pants, jacket fit, missing buttons, frayed braids, condition of black shoes, and any necessary repairs. A parent group then took care of what was needed. (Courtesy of *Tribune Chronicle*.)

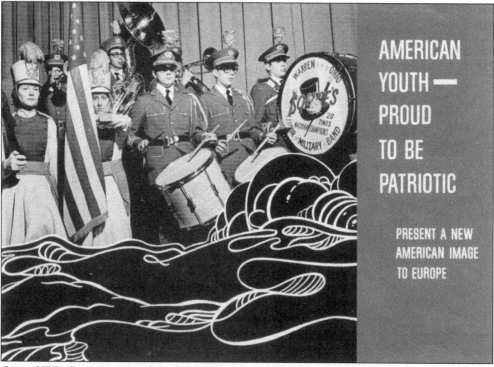

AMERICAN YOUTH — PROUD TO BE PATRIOTIC

PRESENT A NEW AMERICAN IMAGE TO EUROPE

One of WJMB's greatest wishes was fulfilled in 1969 with a goodwill European concert tour. The 105 members left in July for three weeks, performing in the Netherlands, Germany, Austria, France, Italy, and Switzerland, winning great acclaim, and proving they were truly ambassadors of goodwill. Hands Across the Sea was destined from the start to be great, but for European audiences, it was love at first sight.

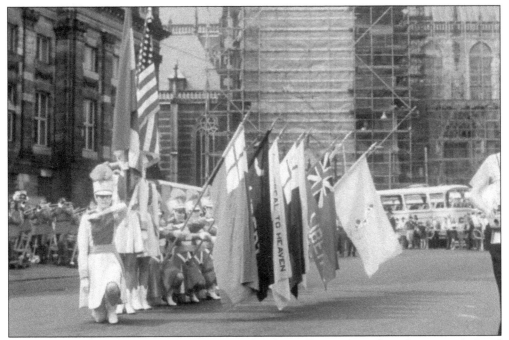

In each country, its national flag was carried in the place of honor. At each performance, the band played the country's national anthem, followed by "The Star-Spangled Banner." In Amsterdam, this brought tears to tourists from Boston who had just returned from another country to cries of "Yankee, Go Home!" The tourists expressed gratitude for how well the band was representing the youth of America.

In Coblentz, the concert venue was on the Rhine for the river festival. Other performances included Osdorf Park near Amsterdam, Castle Gardens in Heidelberg for German-American Day, Town Hall Place in Munich, and town squares in Waiblingen, Salzburg, Klagenfurt, and Florence. At times when parading, the band felt like pied pipers, gathering hundreds of children and adults following behind.

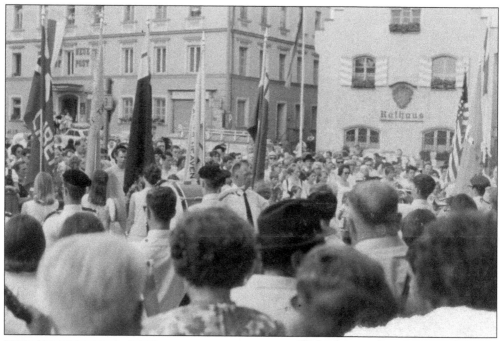

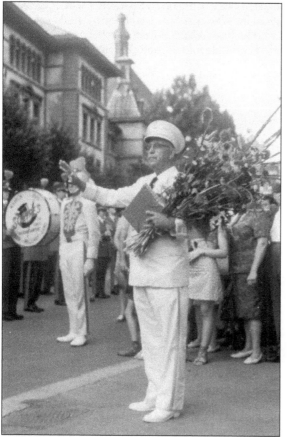

With a bus needing repairs and the town of Holzkirchen, Germany, holding its Costume Day Festival, the tour guide suggested the band join the festivities. Heading toward the town square, the band was quickly surrounded by an enthusiastic audience, applauding, cheering, and tossing hats into the air. Dancing music was requested, and WJMB's own German band obliged. What started as a small parade ended as an afternoon experience that a very happy band would never forget.

During the town square performance in Lucerne, Switzerland, the mayor presented Squire with a phenomenal bouquet of flowers. At the evening concert on Lake Lucerne, the band had a fantastic response from the huge crowd. There were shouts of "Encore! Encore!" When darkness fell, the band played everything in its memory. Dinner that night was very late, but nobody cared. Members were still riding high from another great performance.

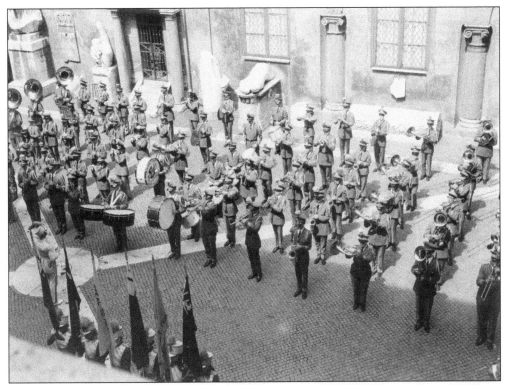

In the Piazza del Campidoglio as guests of the mayor of Rome and other dignitaries, the band was presented with a silver medal commemorating the election of Pope Paul VI. An Associated Press photographer sent a photograph of the concert on the Spanish Steps to all AP newspapers in the United States. The unique photograph showed the crowd reflected in the tubas. News traveled quickly back to the States about the success of the band. Publishing the picture, the *Tribune Chronicle* stated, "All of Warren can be extremely proud of this great organization and join in 'hands across the sea' applause for the magnificent job it is doing in giving our European friends a look at American youth at its finest." WJMB was extremely proud to represent Ohio and the United States. (Below, courtesy of AP.)

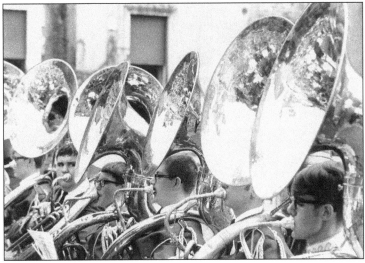

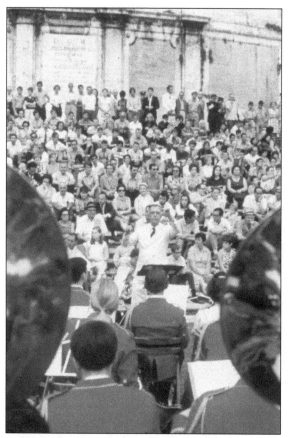

In Rome, the band performed at the Baths of Caracalla and on the Spanish Steps in front of the Santissima Trinità dei Monti as the guests of Vatican reverend Pietro Mercurio, who had heard the band at Mount Carmel Church in Niles. Maj. Giovanni Ruotolo welcomed the band, declaring the bandsmen "presented a new image of America to Rome." It was a great evening! There was thunderous applause when Pete Tokar finished his trumpet solo "Napoli." Even when it was too dark to see the music, the crowd shouted for more. The band played everything in its repertoire, from parade tunes to show music. Sightseeing and learning about different cultures was exciting and important to members and staff. The Colosseum in Rome, the Piazza San Marco in Venice, the magnificent churches, the town squares and markets, and the welcoming nature of the people toward the band proved music is indeed a universal language.

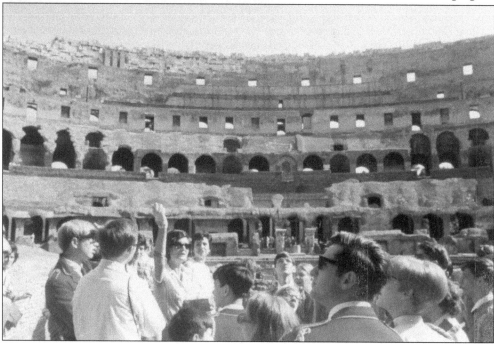

WJMB was fortunate to have three fantastic tour guides. They were always there to interpret and assist as they became part of the WJMB family. With Yap always wiping his brow, after the Vienna concert, his bus presented him with a birthday ice pack to keep him cool. A bond with these tour guides and bus drivers continued with communications for many years.

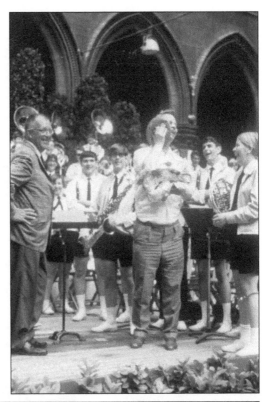

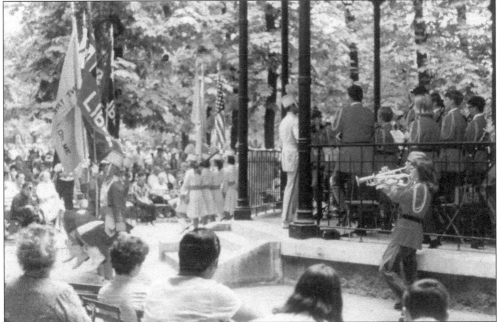

Crowds surrounded the band all around the gazebo at the last performance in the Luxembourg Gardens in Paris. Highlights included a French lady sketching the band and alumnus Jean Farrell traveling from Germany to hear the concert. The field show music, always a hit with audiences, culminated each performance before the national anthems.

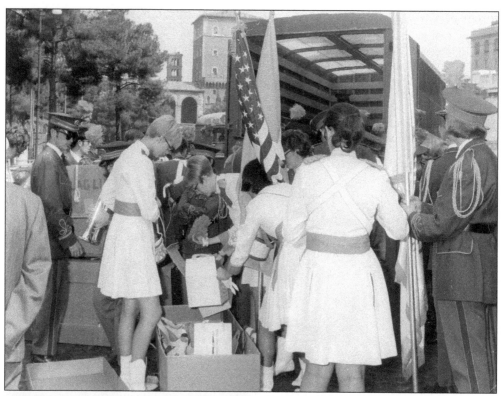

Loading the equipment truck for the last time was bittersweet. Europeans in every city were astounded by the virtuosity of the young musicians. All along the route, they applauded, shouted, and called for encores. With all its championships and accomplishments, the band was certainly used to first-class treatment, but the reception abroad surpassed its expectations.

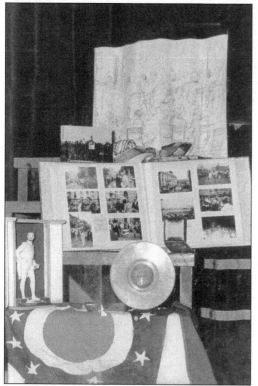

Some of the wonderful memorabilia included the Parisian sketch, a Lucerne photograph, the album from the band's photographer, the statue of Don Giovanni from Vienna, a plate from Waiblingen, and medals from Amsterdam and Rome. Everywhere it performed, the local mayor met the band with a gift from the city. In turn, the band presented a recording and a gift from Ohio.

Four

1970s

Celebrating the band's 50th anniversary and the Queen's Silver Jubilee festivities, the band performed in England, Scotland, and Wales. US travels took the band twice on an eastern tour to Washington, DC, a Lake Erie tour, a western tour highlighted by a concert at Mount Rushmore, and a field show exhibition in Pittsburgh with England's Black Watch and Royal Marine Band. The 1970s was an era of well-known parades: Gimbels Thanksgiving Parade in Philadelphia, Maid of the Mist Parade in Niagara Falls, Hudson's Thanksgiving Parade in Detroit, Salute to Israel Parade in New York City, Christmas Parade in Burlington, Ontario, Miss USA Parade in Niagara Falls, Alexander Graham Bell Parade in Brantford, Ontario, Orange Bowl Parade in Miami, Disney World Christmas Parade in Orlando, Junior Orange Bowl Parade in Coral Gables, Salt Lake City Children's Parade in Utah, Indianapolis 500 Parade, and Pro Football Hall of Fame Parades in Canton for many years. In competition, many awards were won at the Canadian Exhibition Band Contest, Windsor Freedom Festival, Hawaiian International Festival of Music, and the first of many Great Lakes Band Championships in Kenosha, Wisconsin. As always, the band performed locally for veterans, civic celebrations, dedications, festivals, United Appeal and US Bond campaigns, and numerous Fourth of July parades and concerts in Canfield and other areas. Other outstanding 1970 memories included being featured in the *Wonderful World of Ohio* magazine, playing more wonderful Lakeside concerts, and receiving national recognition and awards from the Valley Forge Freedoms Foundation.

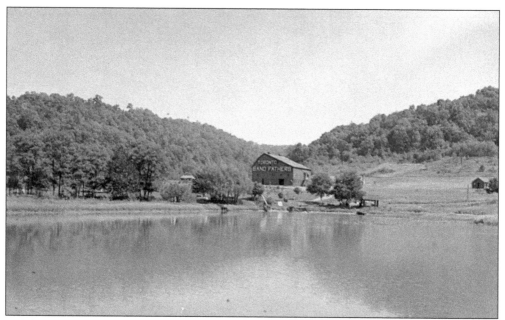

Winding through hills and narrow roads near Toronto, Ohio, the band found a wonderful secluded site for band camp in 1958. There were 142 acres, a four-acre lake, four large cabins, and facilities for staff, cooks, and chaperones. The football field for marching practices had great drainage and was conveniently located outside the dining and rehearsal barn. Band camp remained here through the 1960s and 1970s. (Courtesy of Toronto Band Fathers.)

As field shows became less military, many hours were spent perfecting formations and learning new marching styles. Field show music was more like "Procession of the Sardar," "Sabre Dance," and "Who Will Buy?" Tempos could now vary, but strict American flag competition protocol still had to be followed. Dress-Up Day, Sadie Hawkins Day, Simon Says march-offs, and squad competitions were fun activities. Some members conducted marches to experience what a director saw and heard.

This sketch brings fond memories of Toronto band camp. Concert and sectional rehearsals, talent nights, and dances were held in the big old barn with its high beamed ceiling. Acoustics were good, and there was always excitement when bats decided to take flight. There was Ping-Pong against southpaw Squire, the birdbath, the spillway, learning the definition of "Sir," and changing the stones on the hill to "Squires": On the hill behind the cabins, stones painted white were arranged to show "TBF," for Toronto Band Fathers. When older members arrived the first day of camp, they rearranged the stones to "Squires" and returned them to "TBF" when camp was over. (Courtesy of Tom Dankovich.)

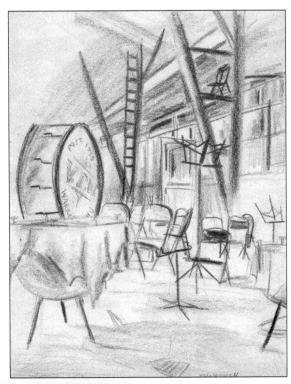

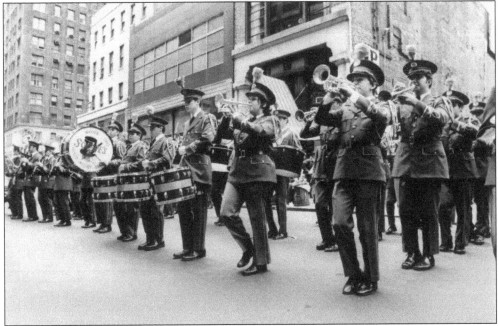

Two major parades, competitions, and 38 local appearances highlighted 1970. The band joined 210 marching units for the Maid of the Mist Parade in Niagara Falls and marched in Hudson's Thanksgiving Parade in Detroit. The February 1970 *Wonderful World of Ohio* magazine features the band, with the article stating, "This great organization just keeps marching along, winning honors, and making new friends wherever it goes." (Courtesy of *Vindicator*.)

The band performed many times for United Appeal banquets and campaigns. The 1970 presentation of the colors by the color guard inspired the audience from the beginning. Performing before a striking red, white, and blue backdrop, the band set the tempo for the evening with stirring marches and flag routines, bringing everyone to his or her feet in standing ovations. (Courtesy of *Tribune Chronicle*.)

Competing in the 1971 Canadian National Exhibition Band Competition in Toronto, the band won both categories entered, becoming the first US band to do so. That year also took the band to Washington, DC, for a performance tour. Highlights included a Pentagon concert, touring historical sights, and attending service band performances. Alumni performing in the service bands at that time included Jim Ognibene (Marine Band), Sam Bauer (Air Force Band), and Don McCurdy (Army Band).

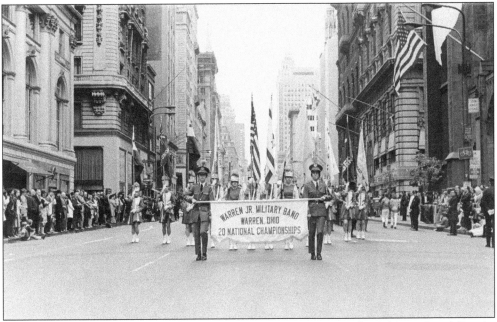

The band was invited to New York City in 1972 to participate in the Salute to Israel Parade, commemorating the 24th anniversary of Israel's independence. Depicted in the parade were peaceful and educational aims, cultural achievements, and biblical and historical backgrounds. Fifth Avenue provided an impressive setting for the parade. A highlight for the band, with heads held high and instruments in place, was carrying its new Duty, Honor, Country flag. Members were able to tour New York City, visit the Statue of Liberty and Rockefeller Center, and attend a Rockettes show at Radio City Music Hall. (Both, courtesy of Ronald Da Silva.)

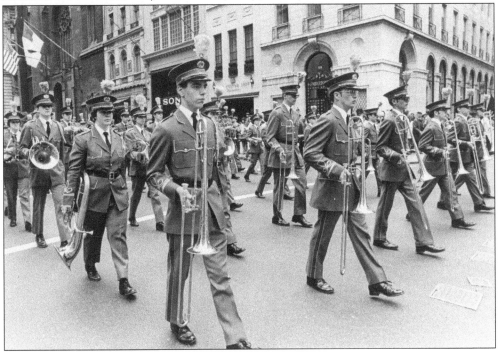

Donald W. "Squire" Hurrelbrink was awarded the highest honor bestowed by the Valley Forge Freedoms Foundation, the George Washington Award, presented at Valley Forge in 1973. Given for the most outstanding individual contribution supporting human dignity and the American credo, Squire's award states: "For dedicated and tireless service as leader of nationally and internationally known Warren Junior Military Band, for sterling principles of loyalty and integrity; For exemplifying the meaning of honesty, sincerity, hard work and pride in accomplishments; For instilling the values of sportsmanship, teamwork and love of country in many young people who were touched by the visible patriotism of this great American." Squire was in illustrious company. Previous recipients include Gen. Omar Bradley, Gen. George Marshall, John Wayne, and John Glenn. The band was also a Community Award recipient for programs promoting the American way of life. The award states: "A stirring musical representation of America at home and abroad created a wholesome image of young people and our nation as dedicated youth radiated pride and respect for our Country, our Flag, and our heritage."

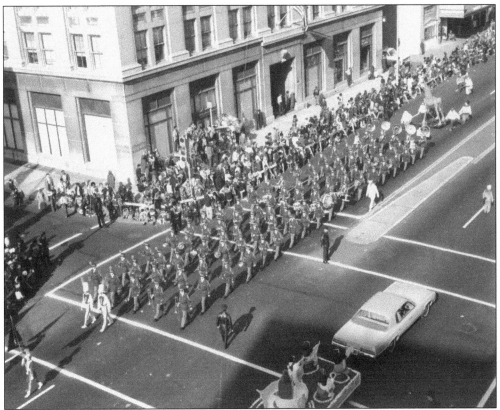

WJMB was one of 24 bands selected to participate in the oldest holiday procession in the nation, Gimbels Thanksgiving Parade in Philadelphia. Animals, the circus, and Disney characters provided the theme for the 1973 parade. The telecast on CBS emphasized the history of the band since 1927 and the recent honors from the Valley Forge Freedoms Foundation.

A 1974 Lake Erie performance tour included the Alexander Graham Bell Parade, concerts in Brantford, Deerfield Village, Lakeside, and Cedar Point, and the Windsor Optimist Marching Band and Canadian National Exhibition Band Competitions. In Toronto, the band garnered two first-place awards and the Canadian National Exhibition Deportment trophy. In Windsor, the band won 10 of 11 trophies.

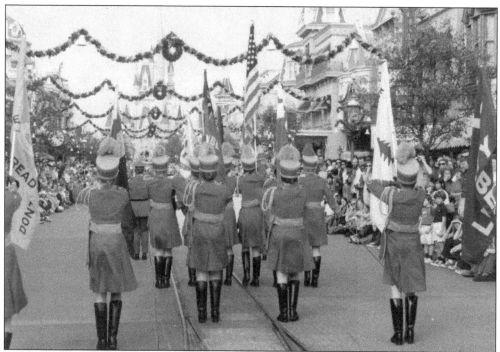

Excitement, holiday cheer, and Disney World fever set the stage when the band marched down Main Street for the Christmas Parade. New color guard and flag line uniforms debuted in 1974 for the Disney, Junior Orange Bowl, and Orange Bowl Parade appearances. Replacing the former white uniforms were red jackets with gold accents, red and gold shakos, black cavalry boots, and French blue skirts to coordinate with the band's uniforms of the same colors. One of 16 bands selected from 157 applicants, WJMB participated in the New Year's Eve Orange Bowl Parade in Miami, receiving the top parade award. During its Florida visit, the band received numerous compliments about its outstanding behavior and how it handled itself in public.

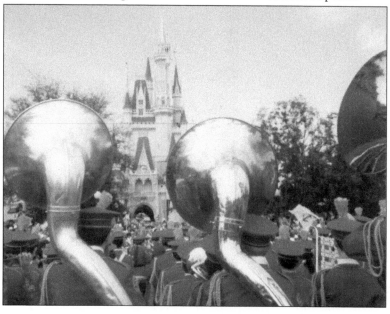

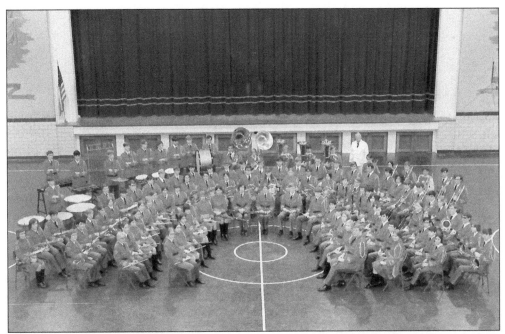

The 1975 annual concert was played in front of a large American flag. Favorite selections included "Barnum and Bailey," "Bugler's Holiday," the finale from the *New World Symphony*, "Cuban Fantasy," *The Blue Danube* waltz, "Trombrero," "The Sinfonians," "Silver Cornets," and "That's Entertainment." A busy summer schedule featured over 25 local engagements, a Lakeside concert, a Marion drum corps exhibition, an Indians game, and the Great Lakes Band Championship. The 1975 band is seen here.

In April 1976, the Fifth Annual Hawaiian Festival of Music featured 1,400 musicians from Hawaii and the mainland, with WJMB scoring highest of all competing units. Highlights included visiting Pearl Harbor and the Polynesian Cultural Center and standing ovations after the Mokuleia Polo Field exhibition and halftime of the University of Hawaii Spring Varsity-Alumni Football Game. Alumni living in Hawaii greeted the current band.

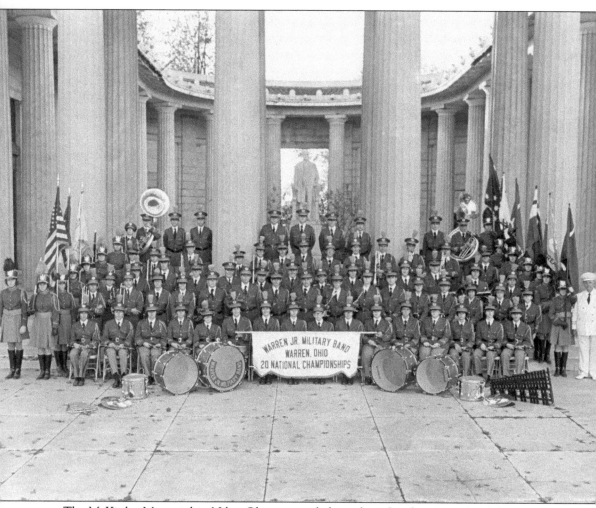

The McKinley Memorial in Niles, Ohio, was rededicated on October 4, 1976, celebrating the birthplace of Pres. William McKinley. A parade through town preceded the rededication ceremony, with many participants dressed in period costumes. During the ceremony, the Niles Bicentennial Chorus sang two of President McKinley's favorite hymns, "Lead Kindly Light" and "Nearer My God to Thee." The band performed two selections from the original 1917 program, "Coronation March" and selections from *Faust*. Robert Taft delivered the identical speech his grandfather, William Howard Taft, had given on October 5, 1917. The Niles Bicentennial Committee displayed an array of historical flags for the event, including what a *Niles Times* article refers to as "the most interesting flag at the 1917 dedication." (Courtesy of Trudi Birk.)

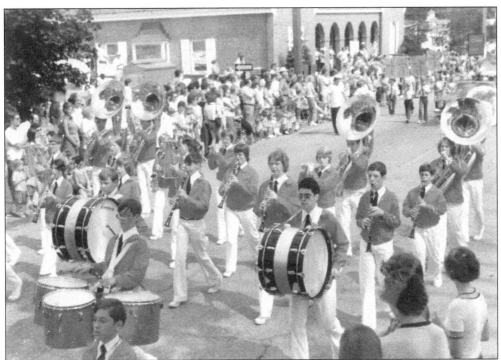

For many years in the 1970s, the Fourth of July began with a morning parade down Route 224 and around the town center in Canfield. Summer uniforms of white pants, white shirts, and red Squire's band jackets were used when temperatures soared, when many performances were on the same day, or when the band was leaving for competition or tour. After parading, the band gathered in front of the gazebo for a concert. The area was always crowded in anticipation of rousing marches, patriotic numbers, selections from Broadway musicals, and soloists showing off their expertise. Sousa's "Stars and Stripes Forever" was a crowd favorite as was the finale of field show music followed by "The Star-Spangled Banner." (Both, courtesy of Trudi Birk.)

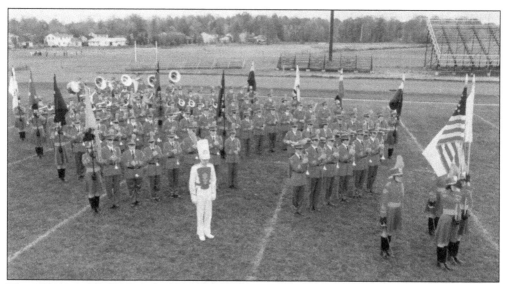

The 1976 Great Lakes Band Championship was held in Kenosha, Wisconsin. WJMB started with a near-perfect inspection followed by a terrific concert. Competing against nine bands, WJMB took first place in the field competition and received the trophy for the most outstanding performance overall. The flag line was now carrying 10 historical flags depicting the era of the Revolutionary War. After Kenosha, inspection of instruments and uniforms was eliminated as part of competition. (Courtesy of Trudi Birk.)

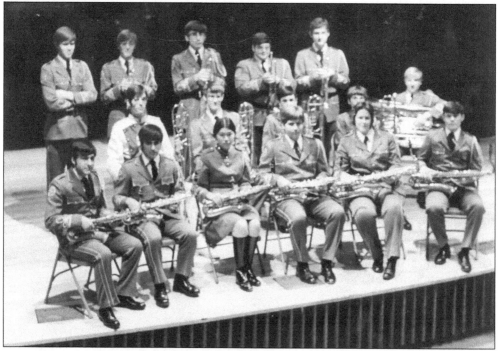

From time to time over the years, members formed a dance band that entertained audiences at annual concerts and other performances. At the band's 50th anniversary celebration concert in 1977, sixteen members entertained the audience with "More," "Corazon," and the big band sound of Glenn Miller's "Moonlight Serenade."

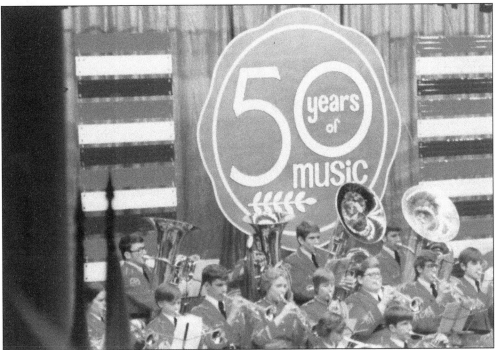

The band's 1977 golden anniversary concert was attended by 2,200. The concert was dedicated to original director Raymond Dehnbostel and to organizer and first band manager Col. Lester Friend. Highlights of the wonderful evening included 14 original members, hundreds of alumni, Nellie Dehnbostel, Wendell Lauth reading the Gettysburg Address with band accompaniment, alumni playing the "Four Hornsmen," and Jean DeMart performing a piano concerto. Much publicity and enthusiasm surrounded the gala celebration. Pictured from left to right spanning the years are Squire, original 1927 member Gene Tropf, and first-year member Rick Beatty. Rick represented the era of second-generation members in the band. The concert committee assembled a program filled with highlights, newspaper headlines, pictures, and memorabilia from different years. (Above, courtesy of Robert McBane; below, courtesy of the *Vindicator*.)

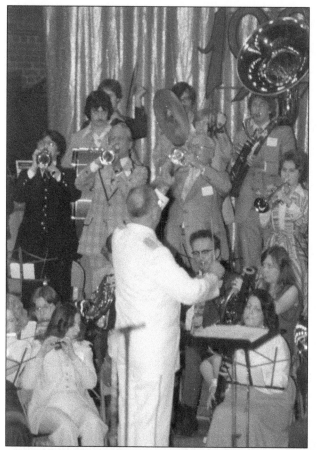

Along with the music of Pyotr Tchaikovsky, Richard Strauss, Sigmund Romberg, Kenneth Alford, and John Philip Sousa, a true highlight of the evening was 14 original members taking the stage to great applause. Several original members and other alumni filled the stage for the playing of "Stars and Stripes Forever," a long-standing tradition at annual concerts. Warren attorney and original member Paul Guarnieri summed up the band's performance this way: "No band plays any better than the Warren Junior Military Band and I've played with and heard some of the best. Fortissimo, pianissimo, forte, no matter which dynamics they play in, they can do it all and do it flawlessly. . . . Putting one's heart into music is what makes the difference." (Both, courtesy of Robert McBane.)

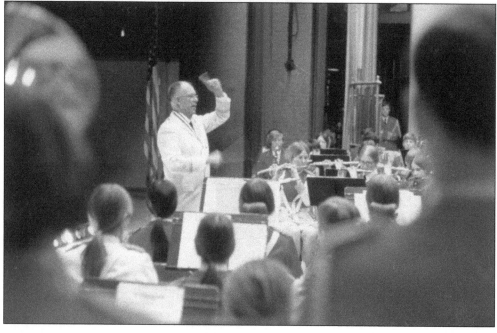

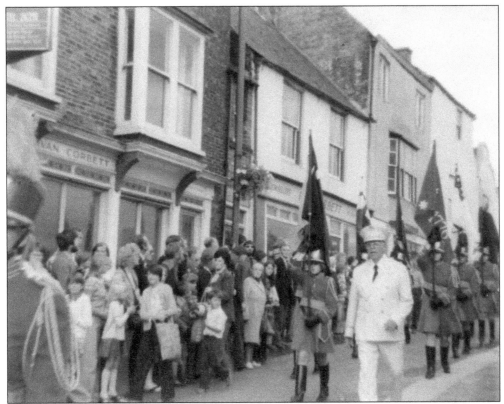

In July 1977, the band traveled to the British Isles for two weeks as part of the Queen's Silver Jubilee celebration. The first performance was in Durham, England, for the Coal Miners' Festival. The band was greeted by Prime Minister James Callaghan, with 100,000 viewing the Gala Day parade. The field show in Durham was performed on a soccer field, with the area getting smaller and smaller as the crowd inched closer and closer. This kind of performance was unique to the viewers, who applauded, surrounded, and hugged band members after the exhibition.

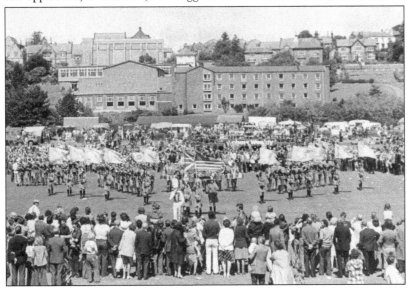

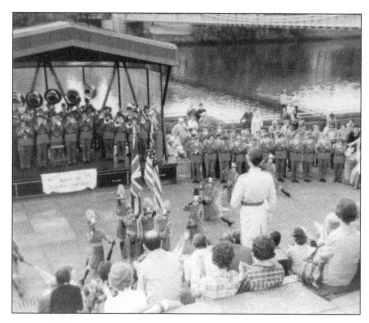

For concerts on the river Thames in London, field show music conducted by drum major Mark Morris and dance band music including "Moonlight Serenade," "String of Pearls," and "Norwegian Wood" were tremendous hits. Carrying the UK flag, the band played both "God Save the Queen" and "The Star-Spangled Banner." The English thoroughly enjoyed "The Standard of St. George March," while the Scots applauded "Scottish Rhapsody."

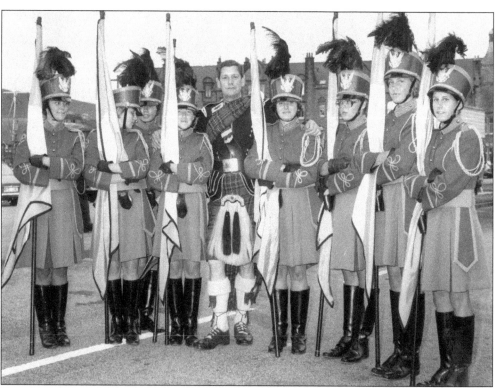

Traveling to the bottom of the Kintyre Peninsula, the band was welcomed by Campbelltown's Scottish Pipe Band and 4,500 cheering citizens. There was a parade through town, a field show, and dance band music. The local townspeople prepared and served the band a special Scottish dinner. One of the Scottish pipers poses with flag line members. (Courtesy of Gordon Hunter.)

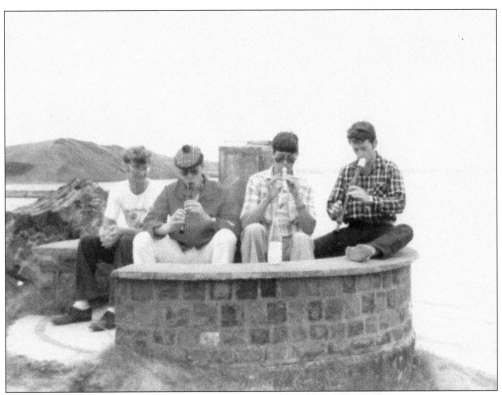

It was not unusual for members to seek out music shops in towns they visited. Recorders in different sizes and tones were purchased by a few members. Here, during free time, an impromptu rehearsal is held on the wall overlooking the beach in Aberystwyth, Wales, as band members learn to play their new instruments.

The final concert was in Barry, a seaside resort in South Wales. It was a beautiful day on the Bristol Channel and a beautiful concert to end the tour. The mayor presented a plaque depicting the history of Barry. Gifts from the tours were treasured and became an important part of the band's memorabilia through the years.

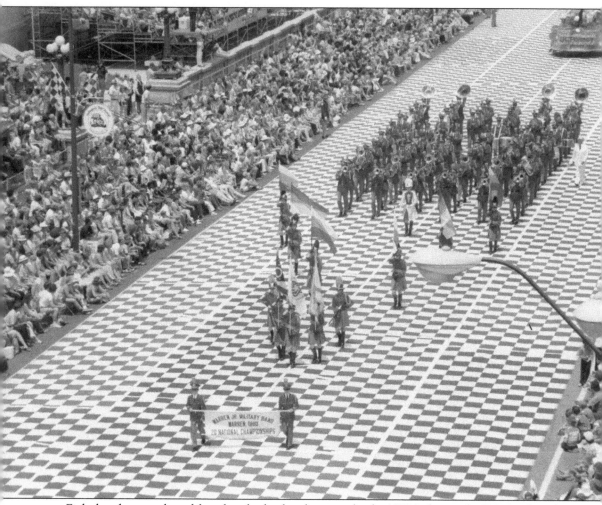

Eight bands were selected from hundreds of applications for the 1978 Indianapolis 500 parade and festivities. WJMB was the smallest of the bands but had the intensity, musicality, and style that the selection committee was looking for. The parade through downtown Indianapolis was held on Saturday, May 27, with the street painted to represent checkered race flags. The pageantry of the prerace festivities for the 62nd International 500-Mile Sweepstakes at the Indianapolis Motor Speedway continued on Sunday with "The Star-Spangled Banner" played by the Purdue University Band, "Back Home Again in Indiana" sung by Jim Nabors, and all bands parading in front of the grandstand and center oval. It was extremely hot that day, and bands felt like their feet were on fire from the intense heat radiating from the track. The crowd was estimated at 250,000, with Al Unser Sr. winning the race. (Courtesy of Indy 500.)

Winning the West with Music was the theme of the 18-day 1978 western performance tour. The thrill of a lifetime came true when the band performed in the amphitheater at Mount Rushmore under the carvings of Presidents Washington, Jefferson, Roosevelt, and Lincoln. The appreciative audience gave several standing ovations. Park rangers commented that they wished the band lived in the area so they could play there every week.

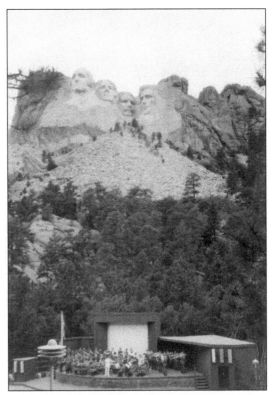

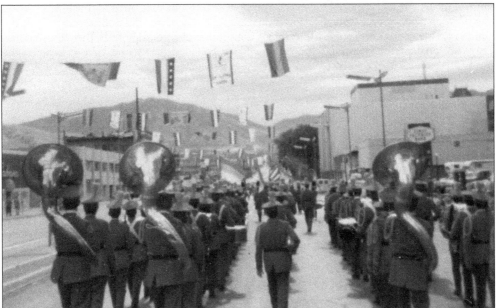

Many concerts, parades, field exhibitions, and jazz band performances were scheduled, highlighted by the German Straussenfaust in St. Louis and the 9,000 Children's Parade in Salt Lake City, with thousands of children marching, singing, and performing along the parade route. A highlight in Las Vegas was a dinner show featuring Doc Severinsen. In St. Louis, band members cruised down the Mississippi River on the *Admiral* riverboat.

One of the band's trademarks was the "tweet, tweet" of Squire's whistle. Anyone who heard it never forgot its unique sound. Someone brought the police whistle back from Chicago in the late 1930s. The whistle had a special tone, and Squire learned to make it tweet and trill in a certain way. Though many tried, no one could ever duplicate the way Squire did it. Blown in 1978 at the Disneyland performance, the whistle caught the attention of three alumni in the park that day. There was no doubt in their minds who had blown it. Following the sound, they soon found the band and reunited with Squire. (Above, courtesy of *Tribune Chronicle*.)

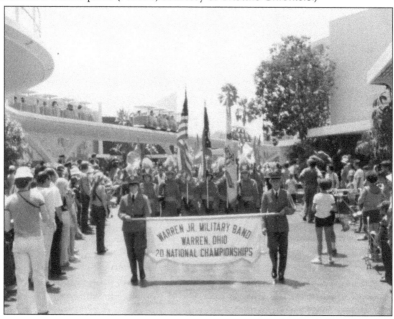

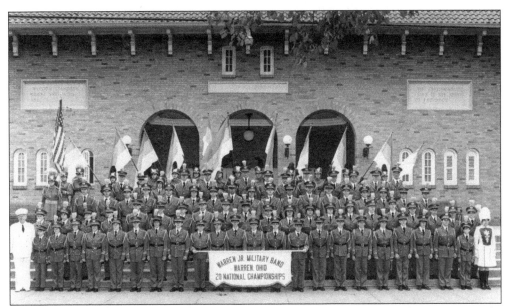

July 4, 1979, was a busy day. The band played a morning parade in Canfield, a concert at the gazebo, and a parade in Austintown, had a quick sack lunch, and then loaded onto buses to travel to Lakeside, Ohio, for its Independence Day celebration. Before the evening concert, members posed in front of Hoover Auditorium. (Courtesy of the Focus Point.)

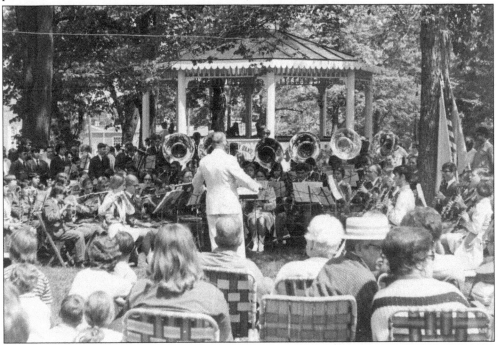

Playing for local celebrations, festivals, homecomings, patriotic festivities, and other events was both rewarding and entertaining for the members. For many years, 25 to 40 local performances was the norm. The band performed in many small communities as well as in larger cities. All audiences received the same high-quality performance. Many performances were in community parks in front of gazebos, such as this 1972 Fourth of July concert.

As part of the 1979 eastern tour, the band performed at Hershey Park, marching a special route and stopping to perform at various locations. Music filled the air as flags and rifles were twirled, spun, and tossed. One of the challenges of such performances was negotiating surrounding obstacles, like the arches in the park.

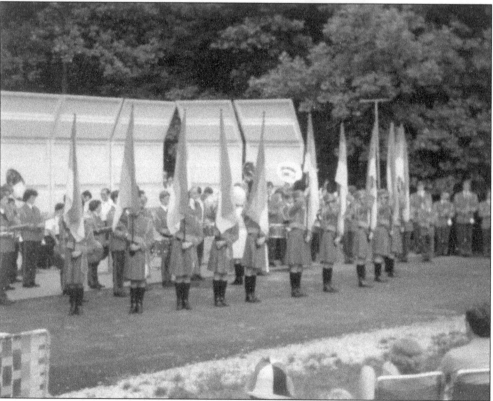

Visiting the Valley Forge Freedoms Foundation was a wonderful experience both musically and educationally. Tour guide Bucky Walters gave members a true historical rendering of living and surviving during the Revolutionary War. Hundreds gathered on the lawn for the band's performance for the Valley Forge Summer Concert Series. Seeing the flags and the band in a semi-circle always meant show music and flag routines followed by "The Star-Spangled Banner."

While in Washington, spectacular settings for concert and field show performances were the Pentagon courtyard, in front of the Washington Monument, and in the Arlington National Cemetery Amphitheater. Works of American composers, patriotic selections, popular Broadway tunes, marches, and selections such as "Dry Bones," "Bugler's Holiday," "Lassus Trombone," and percussion features delighted crowds. When America's favorite John Philip Sousa march was played, audiences always stood and clapped to the beat of "Stars and Stripes Forever." Field show music ended most performances along with, always, "The Star-Spangled Banner." With the thousands of miles traveled, members saw and learned so very much about their wonderful country.

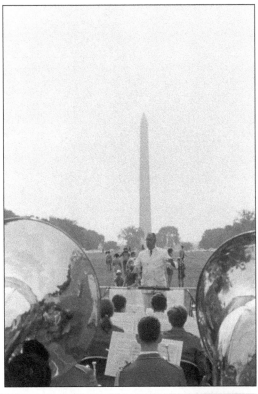

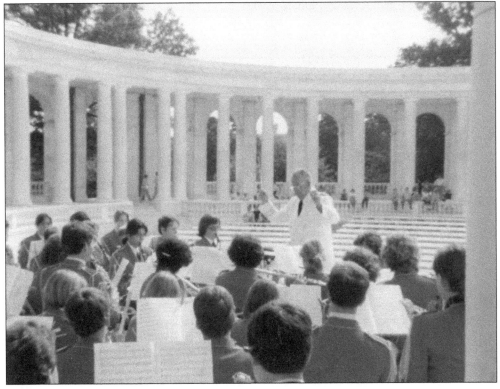

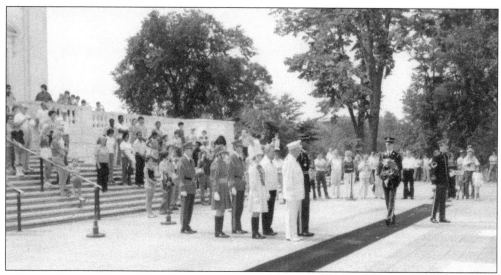

With its patriotic background, placing a wreath at the Tomb of the Unknown Soldier in Arlington National Cemetery was a solemn and moving experience for the band. Forming the honor guard for the band were, from left to right, band member Brad Gessner, color guard captain Sue Costarella, band member Tom Volk, drum major Mila Harkabus, band father George Gessner, Squire, and an Arlington Cemetery guard.

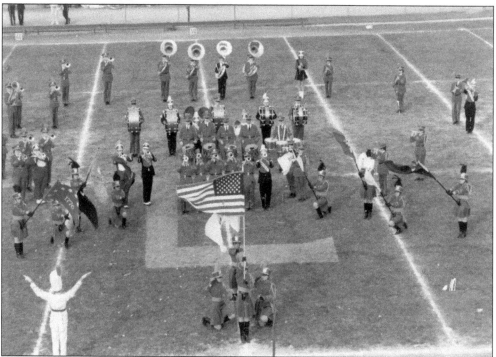

Band night performances began in 1969 with the first show at Warren G. Harding Stadium. That evening, WJMB was honored by the city of Warren for its successful goodwill European tour. From then through the 2000s, band night performances filled the months of August and September. Members came from many different schools and communities, and rarely did members all wear the WJMB uniform, as many were also performing with their high school band.

Five

1980s

The Year of the Squire was celebrated in 1980 with community celebrations, performances on the islands of Oahu, Maui, and Kauai, and marching in Macy's Thanksgiving Day Parade. Locally, the year included the annual concert at Packard Music Hall, sponsoring the 1st Annual Marching Bands in Review at Stambaugh Stadium, numerous parades and concerts in northeast Ohio, and many band nights. Band camp moved to Badger Meadows, where the Donald W. Hurrelbrink Concert Hall was built. There were new drill designers for field shows and new field uniforms; numerous contests in Wisconsin, Minnesota, Michigan, and Illinois; awards for best drum major, best percussion, and most effective color guard; contest grand championships; and warm receptions at the National Cherry Festival. Other travels included the Knoxville World's Fair, an eastern tour of Maryland, Virginia, and Washington, DC, and a western tour with another concert at Mount Rushmore. In 1985, the band won first-place awards in the Midwest and in Europe with performances in Switzerland, Austria, Germany, France, Belgium, and the Netherlands. Band members recall ice-cold, spring-fed showers in Zurich; performing Alfred Reed's *Russian Christmas Music* at the gold-laden Tonhalle in Zurich; the excitement of crowds in Zurich and Kerkrade world competitions; standing in a downpour for results in Kerkrade and only understanding the words "Warren Junior Military Band" and "U.S.A."; and leaving rain-soaked uniforms and percussion equipment on runway in Iceland due to weight. The band celebrated its 60th anniversary in 1987, performing original field show music written expressly for WJMB.

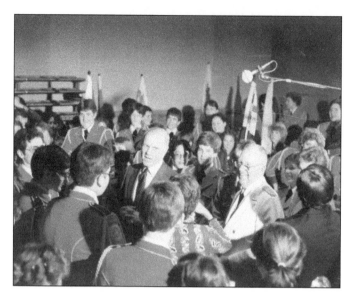

Celebrating his 50 years as director, Squire's Golden Memories was the theme for the 21st annual concert. An honor guard of local service personnel escorted Squire and Sen. John Glenn to the stage. Senator Glenn and his wife, Annie, had come to honor Squire for his many well-known achievements. Senator Glenn met with members before the concert and encouraged them to talk about their Squire. During the concert, he presented Squire with a flag flown over the Capitol.

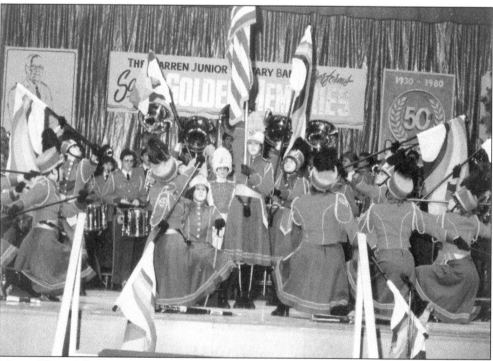

Many of Squire's favorites were performed: the finale from Tchaikovsky's Symphony No. 4, Wagner's "Elsa's Procession to the Cathedral," Liszt's Second Hungarian Rhapsody, and Sousa marches. A true highlight of the evening was Senator Glenn and alumni taking the stage for "Stars and Stripes Forever." Squire was thrilled to see so many of his former members still playing, and they were thrilled to once again play under his baton. The finale culminated with field show music, "The Star-Spangled Banner," and the presentation of the colors.

86

The recognition banquet the night before the concert was a time to say "thank you" to all who gave so much of their time to this organization over the years. Memorabilia, old uniforms, trophies, citations, and pictures completely filled the lobby of Packard Music Hall. Guest speakers and dignitaries were full of praises, with Sen. Thomas Carney's message being, "Squire, don't retire, because we have given you our greatest and most precious commodity, our children to teach." Music for the evening was provided by the Les and Larry Elgart Orchestra. Dave Lewis was general chairman of the 50th-year activities assisted by band parents and community leaders.

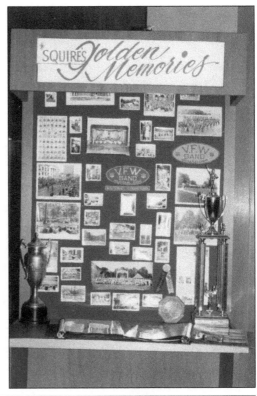

Celebrating Squire's 50 years, the band chose to visit the 50th state, performing and presenting concerts and field exhibitions on three islands. On Maui, the hotel lawn was large enough for both concert and field show performances. Concerts were also played at Maui Surf and Whaler's Village.

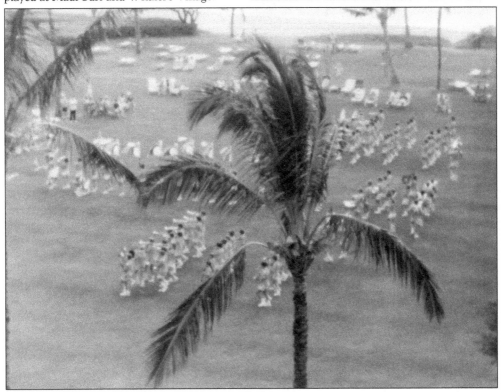

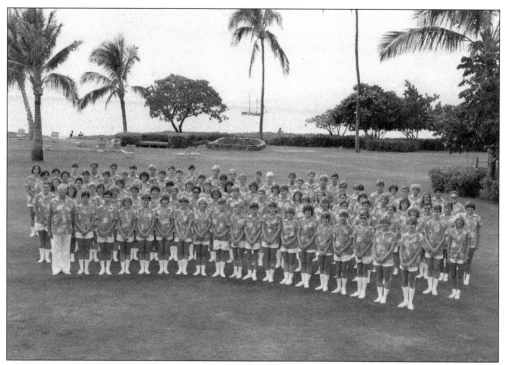

One of the spectacular features of the tour was the tropical summer uniform. Band parent Marge Gessner found the material and designed the Hawaiian shirts. She, Marge Harkabus, and others measured, sewed, and fit every shirt worn by all 104 members. Shirts were worn with pride in Hawaii and when the band returned to the mainland.

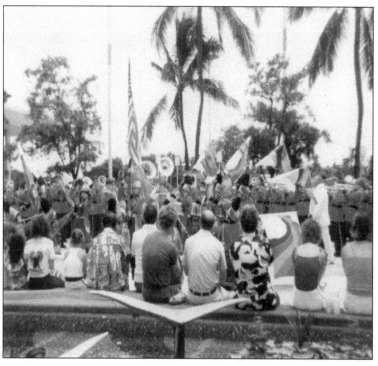

On Oahu, performances included Kapiolani Bandstand, Sea Life Park, Ala Moana Center, and marching a field show exhibition at Aloha Stadium for an Islanders baseball game. There were additional performances on the island of Kauai. Members experienced a luau complete with Hawaiian entertainment and sightseeing on all three islands.

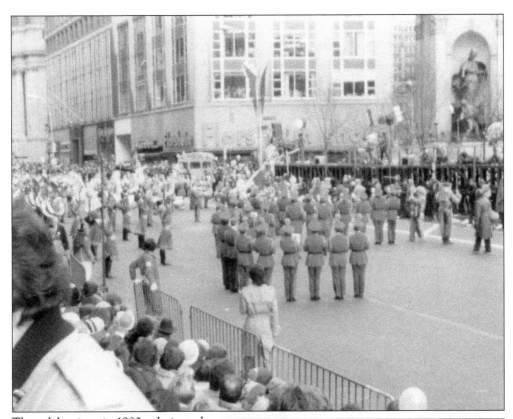

The celebrations in 1980 culminated with Macy's Thanksgiving Parade in New York City. Due to the military bearing and style, WJMB was chosen as the honor band to escort Santa Claus. Television commentary saluted the band and Squire for his long, illustrious 50-year career. "Cordoba" was played for the televised presentation in front of Macy's Herald Square store, followed by the finale from *Christmas Festival*. WJMB then joined the 11 other bands in a combined performance of Christmas songs. The long, exciting day began with a 4:30 a.m. camera rehearsal, followed by the fantastic parade, and finished with a complete Thanksgiving dinner and a Broadway performance of *West Side Story*.

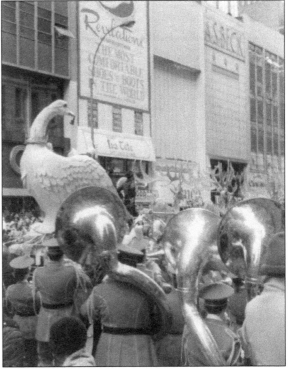

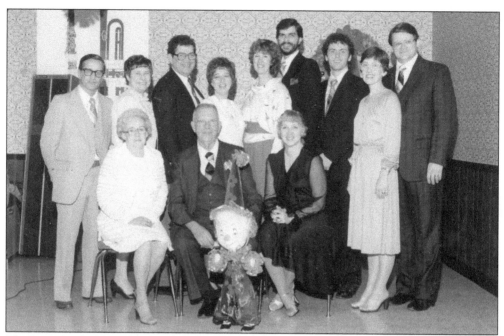

The annual military ball with its traditional grand march was the finale of the 50-year celebration. From left to right are (first row) Shirley Hurrelbrink, Squire, and Pam Edenfield; (second row) Bob and Sue Mayerchak, Dale and Mary Claire Stringer, Janne Hurrelbrink, Bob Morris, Bob Green, and Judy and Bill Gerrity. (Courtesy of Trudi Birk.)

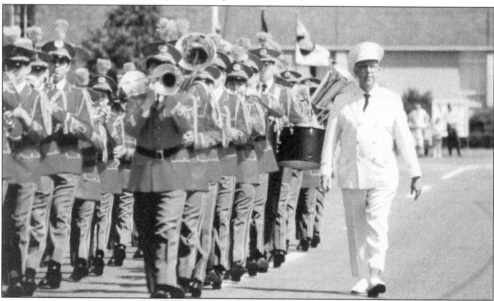

There were more than 38 local performances in a busy 1981, including the halftime show for the Canton Hall of Fame football game (final score: Cleveland Browns 24, Atlanta Falcons 10) and parade, in which WJMB marched for over 10 years. Other new ventures included the Trumbull County Fine Arts Council Noon-in-the-Park Series in Warren, drill designer Paul Neiss writing the field show program for the Great Lakes Band Championship, and new field uniforms. Shown here, Squire always marched in parades with the band until his doctor finally said "no more."

Rehearsals were held in the St. Mary's Middle School gymnasium in Warren in the 1970s and 1980s. Formal pictures were often taken around the corner on the steps of St. Mary's Church. This 1982 band had a wonderful surprise for the 2,000 people attending the annual concert. New field show instruments making their debut included upright basses, marching baritones, marching French horns, field drums, a marimba, a vibraphone, a xylophone, and marching bells. (Courtesy of Trudi Birk.)

In 1982, for the first time, the band competed in the Flags of Freedom Festival in Sun Prairie, Wisconsin, receiving the first-place concert trophy. In July, it performed at the Knoxville World's Fair, enjoying a side trip to Mammoth Cave. In September, the band sponsored the First Annual Marching Bands in Review at Stambaugh Stadium in Youngstown with performances by nine area bands. (Courtesy of 1982 World's Fair.)

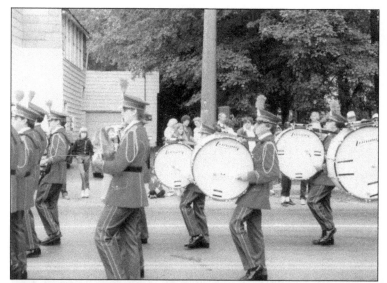

In September, the Falling Leaves Festival in Salamanca, New York, featured a parade and field show competition with bands from Ohio, Pennsylvania, and New York. In keeping with its tradition of excellence, WJMB won parade, field show, best percussion, drum major, and best guard trophies for several years in Salamanca.

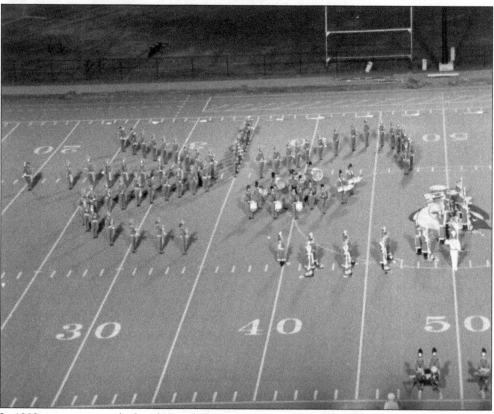

In 1983 competitions, the band played "Florentiner March" and *Mannin Veen*. One judge noted: "Awesome performance! By far the finest concert band performance I have ever witnessed in a contest." WJMB was named Flags of Freedom Grand Champion in Sun Prairie. Other awards included Most Effective Color Guard, Best Percussion, and Jeff Lewis as Best Drum Major in every competition. Field music included "Holst I" and "Holst II," "Concert '83," and "Come In from the Rain." (Courtesy of Trudi Birk.)

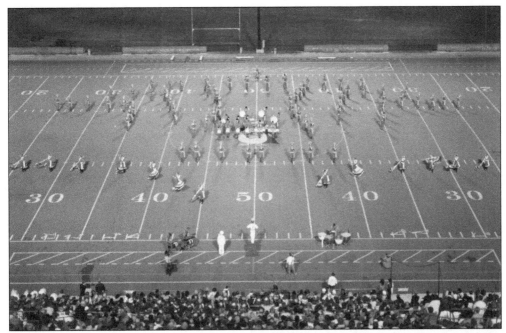

With the 1984 field show, the band continued its winning ways in Wisconsin competitions with concert, field, and overall trophies, along with color guard, percussion, and drum major awards. Field music featured "Strike Up the Band," "Simple Gifts," "Concert '83," and "Blue Moon." Thirty local performances highlighted the summer as well. In the Cleveland Budweiser 500 parade, the band won the overall sweepstakes award, best band, and best color guard. (Courtesy of Trudi Birk.)

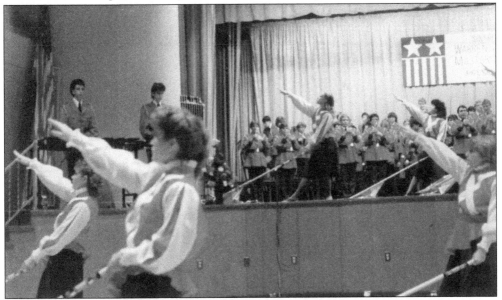

Spirit of America, the 1985 annual concert theme, began a year of exciting performances in the United States and Europe. "Eaglecrest" and *Russian Christmas Music* were previewed on the concert as summer competition selections. WJMB was chosen to compete in the World Music Festival in Kerkrade, Netherlands, and would represent the United States at the International Youth Music Festival in Zurich, Switzerland.

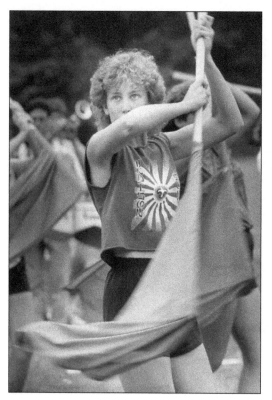

The band met every challenge it was given that year in preparation for its Midwest and European competitions. Extra rehearsals, minicamps, and marching practices were all in pursuit of the goal. The intensity for perfection in the field show that year could be seen on the face of each member. Pictured at left is Beth Ann Gerrity on flags; below are Mike Harlan (left) and Kevin Chiu on mallets. The music for the 1985 show, arranged by Rick Kirby, was based on American tunes: "Summertime" and other songs from *Porgy and Bess*, "Ai No Corrida," "Simple Gifts" from *Appalachian Suite*, and a color presentation to "Battle Hymn of the Republic." Music was phenomenal, drill design was exceptional, members were totally focused, and soloists played with their hearts and souls. (Both, courtesy of *Tribune Chronicle*.)

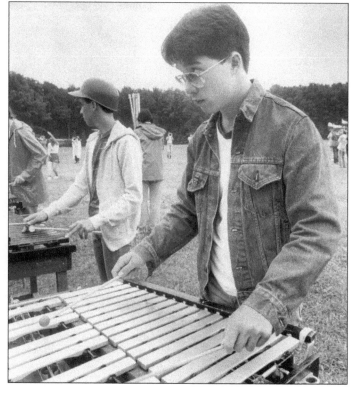

A shortened Midwest competition circuit was both exciting and rewarding for the 116 members. With competitions in Waunakee, Dundee, and Sun Prairie, WJMB took top awards in concert, parade, and field shows as well as trophies for best color guard, best marching score, and Flags of Freedom Grand Champion. Since Squire was not able to travel to Wisconsin, an excited group called him to say, "We won for you!"

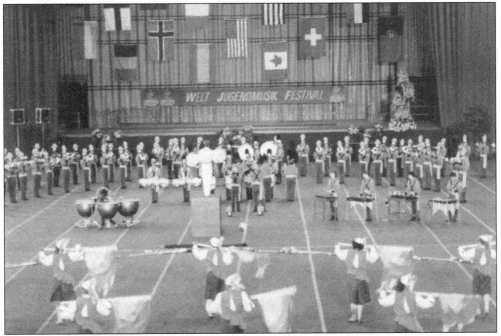

The International Music Festival in Zurich featured 54 groups from 22 countries, with many performing for the opening ceremonies. No member will ever forget the field show performance at the Hallenstadion. The band received a 15-minute standing ovation, with all in the entire crowd stomping their feet and shouting "U.S.A.! U.S.A.! U.S.A.! Encore! Encore!" The award stated, "Most Effective and Spectacular on the Field."

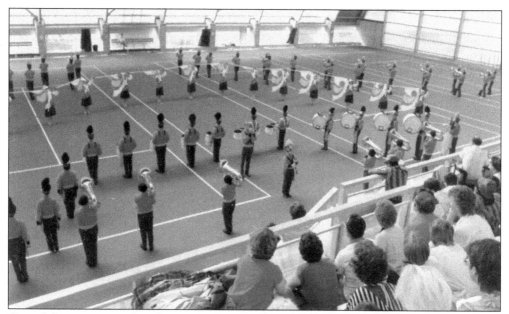

One of the most unusual performances ever was the field show on an indoor tennis court arena in Zurich. Volume, intensity, step size, and footwork had to be adjusted. The width of the arena worked, but the tennis courts definitely did not have the depth of a normal field. All in all, it was an exciting and phenomenal performance, thoroughly enjoyed by the audience.

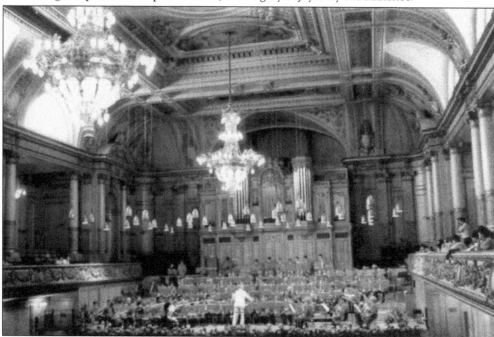

Concert competition was at the Tonhalle, an ornate Zurich concert hall. A.J. Hoefer conducted "Eaglecrest," the required selection for Kerkrade. An exciting performance of *Russian Christmas Music* was conducted by Squire, recently recovered from heart surgery. When the performance ended, there was not a dry eye among band members, staff, or parents. The entire audience was on its feet applauding.

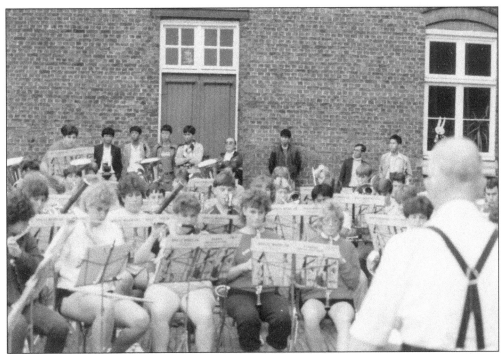

With over 3,000 performing in Zurich, when time was available, musicians gathered to listen to rehearsals from bands of other countries. Thai friends enjoyed attending WJMB rehearsals. After the tremendous field show response from the crowd, a cameraman from Band of Indonesia recorded every rehearsal and performance of WJMB.

The 1985 field show took top honors everywhere it was performed. Part of the 1985 performance staff is shown from left to right: Rick Kirby, field music arranger; Tom Volk, visual choreography; A.J. "Buz" Hoefer, field design choreographer; and Fred Morris, percussion instructor. Along with other instructors, they made quite a championship team.

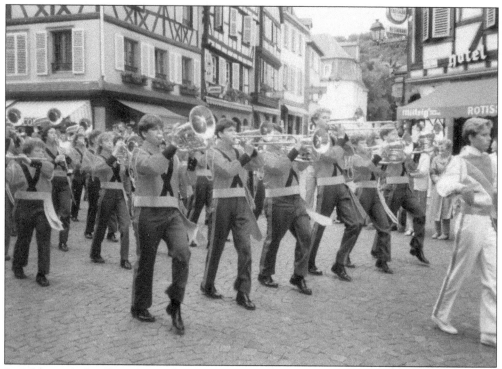

In Salzburg, the band participated in the MusikParade, gathering crowds on its way to a concert at the Kongresshaus. Innsbruck featured a performance in the Mirabel Gardens, followed by concerts in Munich at the Musikpavillion and Schrannenfestaal, in Strasbourg at the Pavillon Josephine, and in Brussels at the Grand Place. A full field practice was also held on the cobblestones at the Grand Place with hundreds watching.

With large posters promoting the band as part of its summer concert series, the town of Obernai welcomed WJMB for dinner, concert, and field music performances at the Town Hall Square. Then it was on to Paris for a concert in the Luxembourg Gardens, where members and Squire were presented flowers and signed hundreds of autographs.

The World Music Festival in Kerkrade, Netherlands, was the final destination. The concert was held in the Rodahal with the march past and field competition at the huge Municipal Sports Grounds. Before 35,000 attending the competition, the march past, led by drum majors Ruth Ann Beatty and Don Malarcik, featured the music "Simple Gifts." A tremendous ovation was received for the spectacular field show performance. In a total downpour, after interpretation, the band learned it had won the gold medal for both march past and field show and the silver medal for concert. Out of 147 bands from 23 countries, WJMB finished highest overall—a wonderful accomplishment! The entire 1985 WJMB field show can be viewed on www.youtube.com. (Both, courtesy of Foto Vinders.)

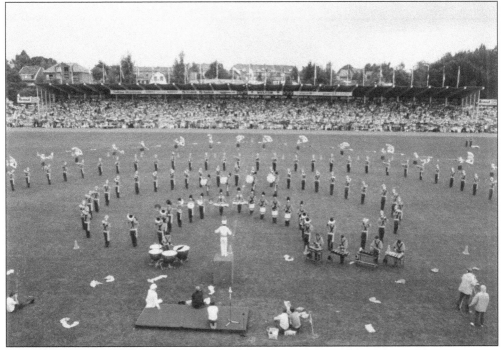

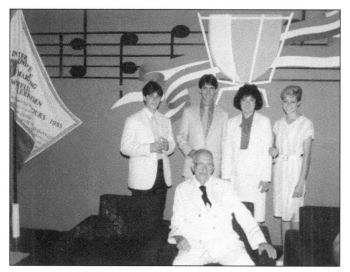

The Kerkrade World Music Festival is held over four weekends every four years. American organizations are carefully screened and selected by a panel of judges and university professors, with only a few being chosen. Proudly posing by the official flag and symbol of the World Music Festival are Squire (seated) and, standing from left to right, Henry Cartwright, Don Malarcik, Lia Pagano, and Ruth Anne Beatty.

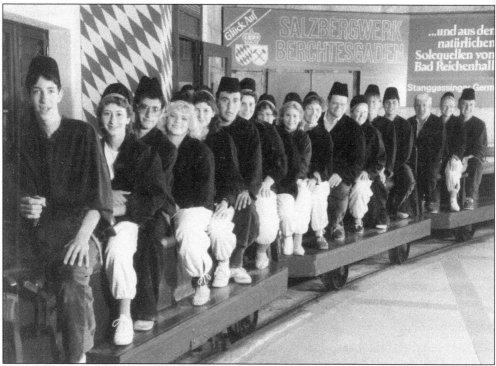

Even with rehearsals and many performances on the schedule, there was still time for enjoying many wonderful European sights. Among these were city tours, the marionette theater's *Barber of Seville*, and visits to Liechtenstein, Neuschwanstein Castle, Lake Chiemsee, the Hallein Salt Mines, Munich's Hofbrauhaus, Versailles, Chartres Cathedral, Luxembourg, and Iceland. (Courtesy of Hallein Salt Mines.)

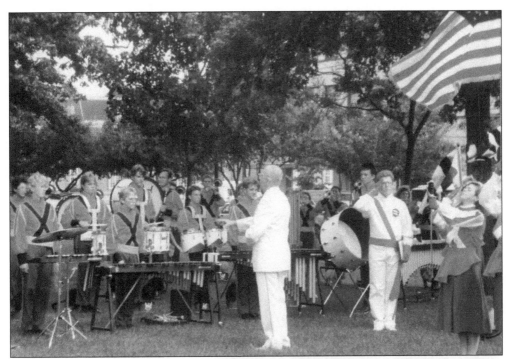

The Noon-in-the-Park summer concert series, sponsored by the Trumbull County Fine Arts Council, was a summer highlight for over 20 years. The flag performance, accompanied by the field show music, was a crowd favorite. In 1986, field show music featured Rick Kirby arrangements of "Wasps," "Ai No Corrida," and "Somewhere," another entertaining show winning many awards.

WJMB received a standing ovation after the field performance at the 1986 National Cherry Festival in Traverse City, but the crowd was shocked when it was announced the band had finished in second place after beating the Band of the Black Watch all season by 10 to 15 points. With heads held high, WJMB just took top honors in the Cherry Royale Parade the next day and won the Governor's Trophy for the overall championship. Holding the trophy is business manager Leo Hermann.

The 1987 Diamond Jubilee Concert celebrated the band's 60th anniversary. Members performed original field show music entitled *Mount Olympus Suite*, composed by Rick Kirby. "Prologus and Fanfare," the entrance of the gods, evolved into "The Conflict," with forces of good and evil locked in a ferocious battle. With the victory of Apollo over Hades, "Joyant Celebration" led to the finale, "Enchanted Journey." (Courtesy of Bob Mayerchak.)

Members pose with trophies, including best flags, drum major, percussion, marching, and music, won at the 1987 Summer Marching Bands of America finals, Flags of Freedom Competition, Minnesota Sweepstakes, and National Cherry Festival parades and contests. Backward marching, continuous tempo changes, and six different flags highlighted the performances. That year, the Traverse City headline read: "Warren Wins!" With the band making a clean sweep in concert, parade, and field, the crowd was elated.

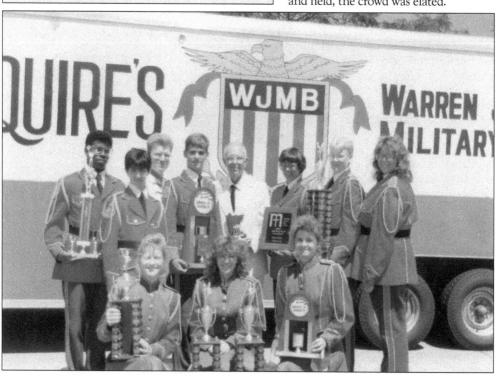

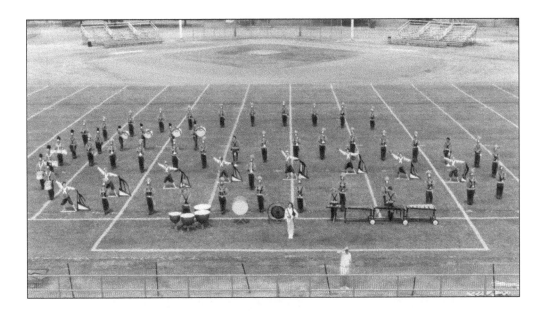

The 1988 summer tour was divided into two parts. A 12-day competitive performance tour in Illinois and Wisconsin, including the Summer Marching Bands of America finals in Whitewater, was followed by a trip east where the band participated in the Fourth of July parade and celebrations in Pittsfield, Massachusetts. In Eastover, a concert preceded the field show music of "Who Will Buy?" and "American Folk Rhapsody." In Boston, members walked the Freedom Trail, visited Boston Common, Boston Garden, the Old North Church, Paul Revere's Home, and the USS *Constitution*, and enjoyed time at the beach.

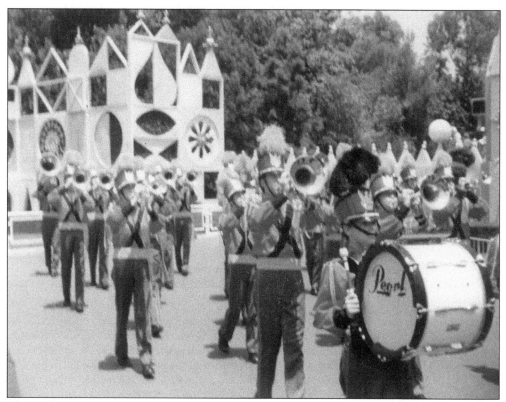

The 23-day summer tour began with competitions in Wisconsin and Minnesota, and then the band traveled west. The first stop was a western show in South Dakota and another wonderful concert at Mount Rushmore, followed by performances in Cheyenne and Salt Lake City for the annual Children's Parade, a visit to Las Vegas, and a trip to Anaheim for a Disneyland Music Workshop and parade. The field show music was performed on the deck of the *Queen Mary*, permanently docked in Long Beach, California. A free beach day meant swimming, volleyball, sunning, and a cookout prepared and served by staff and chaperones. The final tour days were spent at the Grand Canyon in Arizona and in New Mexico, Oklahoma, and Missouri, with additional performances along the way. The 1989 show featured the original compositions of Rick Kirby entitled "The Vision," "Bittersweet Samba," and "Crystal Dawn."

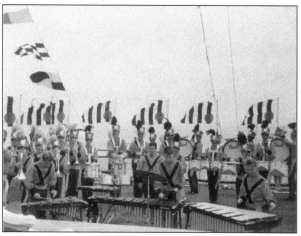

Six

THE LATER YEARS

This was an era to celebrate the band's 65th, 70th, 75th, and 80th anniversaries and Squire's 60th and 65th years as director. Many traditions continued: band camp at Badger Meadows; annual concerts; numerous awards for concert, field, parade, drum major, color guard, and percussion; performing for local parades, concerts, and festivities; sponsoring Marching Bands in Review at Stambaugh Stadium; marching many local area band nights; and playing Christmas concerts at Powers Auditorium and other locations. Travels and competitions continued, mainly in the Midwest, with appearances in Canada and the western United States. With two excellent field show designers, exciting features were theme-oriented music, all original music, new concert and field uniforms, constantly changing color guard uniforms and flags to coordinate with shows, and a percussion pit growing in numbers and creativity. Several highly entertaining shows featured the music of *Hook*, *Far and Away*, and *Robin Hood*, well-known popular tunes, and works of composers like Leonard Bernstein. Minicamps became the norm during the winter and spring, with several alumni joining the staff to assist with conducting and field shows. After 1996, alumni, other staff, the band manager, and the field show director led the way in continuing Squire's legacy. After Squire passed in 1999, the band formed an honor guard for its beloved director and played a memorial concert in his honor. In later years, a formal alumni organization and website (wjmbalumni.org) were formed, a memorial scholarship was established, and a home for band memorabilia was found.

With the Toronto camp closing, a new location for band camp was found at Joseph Badger Meadows in Burghill, Ohio, in 1981, and continued here through the first decade of the 2000s. Practice fields were fine, but a solution was needed for a rehearsal hall. Band parent and architect Russ Beatty designed a separate building attached to the dining area. This was built and named the Donald W. Hurrelbrink Concert Hall. The picture shows Patrick Misel getting a band haircut at the entrance.

Typical camp schedules included reveille, calisthenics, flag raising, breakfast, cabin inspection, concert rehearsal, free time, lunch, section and marching rehearsals, recreation time, flag lowering, dinner, rehearsal, sometimes a special event such as a talent show or campfire, call to quarters, and taps. Shown here is a rehearsal conducted by Paul Brizzi in the concert hall.

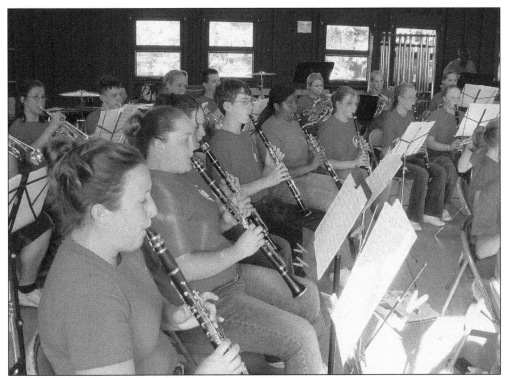

Visitors day at camp saw alumni, parents, and friends enjoying an afternoon concert and previewing parade music and the new field show. Field shows meant hours and hours of marching and music rehearsals along with additional flag and percussion rehearsals. The effort members put into preparation of these shows was extraordinary. Members aged 12 to 21 all learned very quickly what it took to be a championship band. WJMB members became family. They made camp, tour, rehearsals, and performances special. Most learned WJMB's show in addition to their high school band's halftime shows. The sense of dedication and loyalty kept many members staying for five or more years. "Stand By Me," *The Mission*, and "Ave Maria" became favorite field show warm-up numbers.

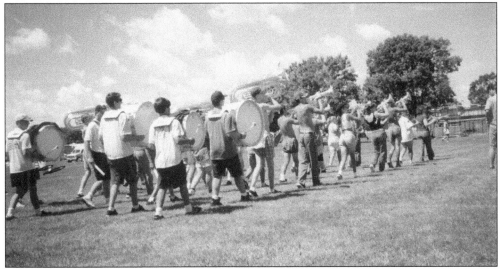

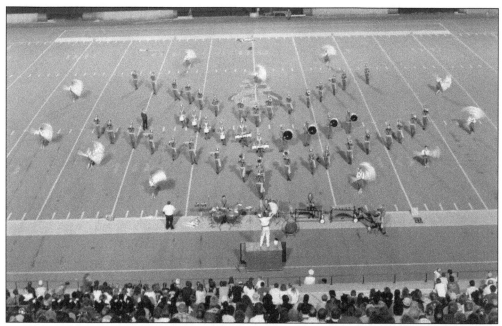

In 1990, visual design and original music by Rick Kirby were written in praise of America's heritage and the strength of America's ethnic diversity. "The Vision," dedicated to the worldwide fight for human rights, was followed by "From Many . . . One," showing a few of the many influences brought to these shores molding Americans into one people. That summer, WJMB hosted 10 Midwest bands for the Banners and Brass competition. (Courtesy of Trudi Birk.)

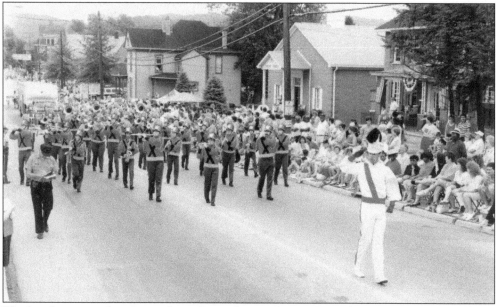

The band is pictured in Canonsburg, Pennsylvania, for its 1991 Salute to Veterans July Fourth celebration. Festivities included a parade, concert, and field show to music of "Scream," *Chorale and Shaker Dance*, *Celebration Suite*, and "Do Ya Wanna Dance?" That summer was the first for new field show music and design by Paul Brizzi and the first of several yearly performances for the Kent State Ashtabula Campus Summer Concert Series. (Courtesy of the City of Canonsburg.)

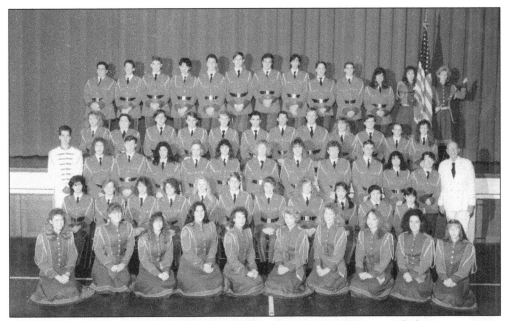

The 1991 annual concert was a tribute to military personnel, veterans, and alumni serving in the Persian Gulf. "God Bless America" opened the program, followed by the five service marches with each service color guard presenting its colors. The "Greater Clarksburg March" by Virgil Bork was a unique opportunity for assistant director Jeff Lewis, as the march was composed by his great-great uncle in Clarksburg, West Virginia. (Courtesy of Trudi Birk.)

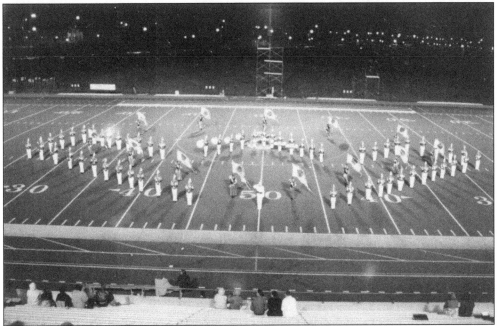

Celebrating the band's 65th anniversary, the 1992 field show opened with "Jupiter" from *The Planets*. Following were the familiar tunes "Are You Lonesome Tonight?," "School's Out for Summer," and "See You in September." Enhancing the visual design, alumnus Tom Volk created blue moon flags, stylistic replicas of school buses, and various colored autumn leaves for the closing number.

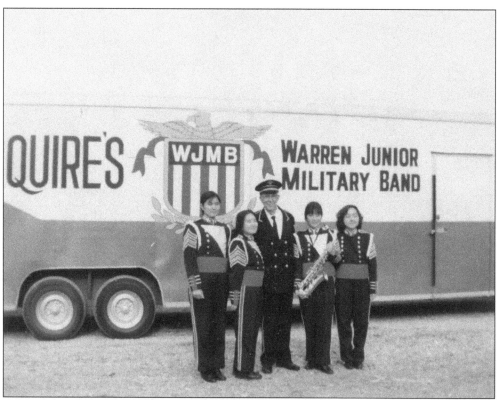

Members wore new uniforms in the summer of 1992. White trousers and navy coats, with or without a silver triangle, and attached red cummerbunds were mainly for field shows and parades. Navy pants and coats presented a more formal look. Along with Squire (center), four exchange students performing with the band that year are shown from left to right in the new uniforms: Ako Toma, percussion; Akiko Takeski, tuba; Erika Taniguchi, saxophone; and Maki Hatakegama, percussion.

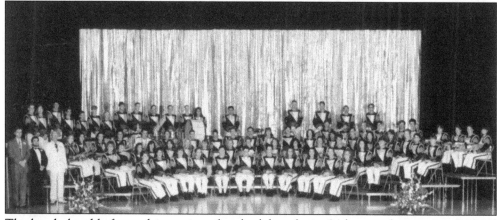

The band played before a shimmering silver backdrop for its 34th annual concert at Packard Music Hall in 1993. Some selections included "March of the Belgian Parachutists," *Symphonic Festival*, "Salvation Is Created," selections from *Robin Hood* and *My Fair Lady*, "Ave Maria," and *Opera Mirror*, showcasing well-known opera melodies. Assistant directors Chris Barbero and Jeff Lewis shared the conducting duties with Squire. (Courtesy of Trudi Birk.)

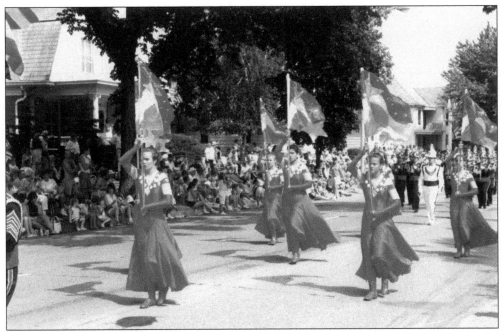

In 1993, the color guard debuted new red uniforms designed by Tom Volk. The stunning uniforms were a hit on tour and in Traverse City for the National Cherry Festival, which included the Heritage Parade, concert competition, Junior Royale Parade, field show competition, and Cherry Royale Parade. Placing first in the open band competition, the field show featured "Moorside March," "La Fiesta Mexicana," *Celebration Suite*, "Sunrise Lady," and "Where Is the Love."

In the 1980s and 1990s, much of the band's travels were with the Mid-American Competing Band Directors Association (MACBDA). MACBDA was a summer concert, parade, and field show competition circuit with contests primarily in Illinois, Indiana, Iowa, Michigan, Minnesota, and Wisconsin. Bands were judged on execution, visual analysis, general effect music, general effect marching, and caption awards for drum major, color guard, and percussion. Practice facilities were always available, as shown in this Sun Prairie concert rehearsal.

M.A.C.
1995 National

Following the entertaining 1994 field show of *Far and Away*, the 1995 field show was performed to *Hook*, the modern-day Peter Pan. Pit players, dressed in stripes with their percussion equipment and toys, added fun and enthusiasm to the band's interpretation. Flags, sabers, field musicians, and percussion were all part of the visual creation. Music included "Prologue," dastardly "Smee's Plan," "Time-Out Interlude," "Banning Back Home," and Peter Pan's victorious defeat of Captain Hook, entitled "You Are the Pan." The show evolved with drum major Scott Woodyard as nasty

Captain Hook, raucous pirates on the sideline, Tinkerbell, and the most wonderful character of all, drum major Robert Viets as Peter Pan, proving once again that good triumphs over evil. The show was pure entertainment from the first note to the last. That year was the ninth time the band was crowned Flags of Freedom Grand Champion. The tour included 4 concerts, 12 parades, and 15 field shows. (Courtesy of Empire Photography.)

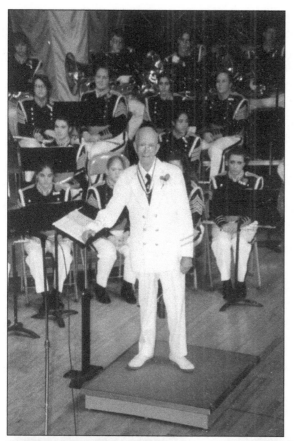

The 1995 annual concert, Legacy of Excellence, honored Squire in his 65th year as director. There were many congratulatory letters, memorabilia, and speakers from the different eras. With Jonathan Willis as assistant, concert selections included "Liberty Bell March," selections from *Phantom of the Opera*, Allegro from Mozart's Horn Concerto, "To Tame the Perilous Skies," "America the Beautiful," the finale from the *New World Symphony*, jazz ensemble selections, and alumni once again filling the stage to play "Stars and Stripes Forever" under Squire's baton. Interviewed at age 86, Squire stated, "I've stayed with this because I feel as though I had something to give. I love music and I'd rather be with these kids than anyplace else. This is a very fine organization. I think I've done a lot of good over the years." Members, parents, and alumni could not agree more.

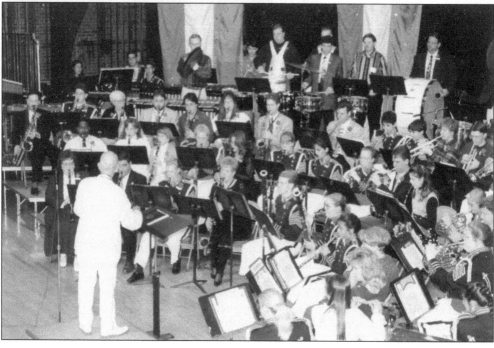

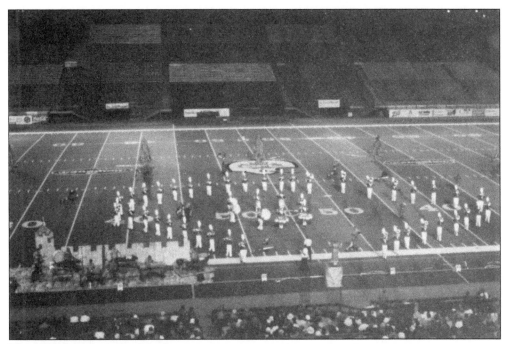

The 1996 field show was based on the movie *Robin Hood, Prince of Thieves*, with musical arrangements by Rick Kirby and drill design by Paul Brizzi. Selections included "Overture," "Escape to Sherwood," "Maid Marian," "Abduction," and "Final Battle." Tom Volk created the backdrop of 10-foot-tall trees made of green lamé material. WJMB traveled far and wide that year to perform in concerts, parades, and field shows in Illinois, Wisconsin, Iowa, North and South Dakota, Saskatchewan, and Manitoba. Sightseeing experiences such as Wall Drug, the Badlands, Custer State Park, Buffalo Gap National Grassland, the Black Hills, and Devil's Tower were highlighted by a return to Mount Rushmore for the band's third performance there. Assistant director Mike Westmoreland is pictured at the podium.

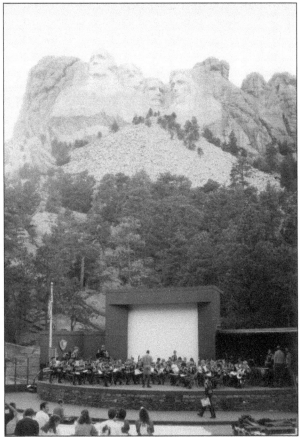

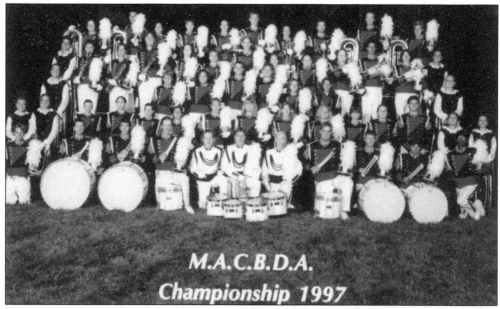

M.A.C.B.D.A.
Championship 1997

Terpsichore provided the music for the 1997 field show. The original music, first published in Germany in 1612, was a suite of Renaissance dances from the French court of Henry IV. Based on the modern-day version, Joel Poppen, Paul Brizzi, and alumnus Vince Pitzulo arranged the music for the WJMB show. Tour that year included 18 performances highlighted by drum corps exhibitions and the Brass Theater at Illinois State University. (Courtesy of Empire Photography.)

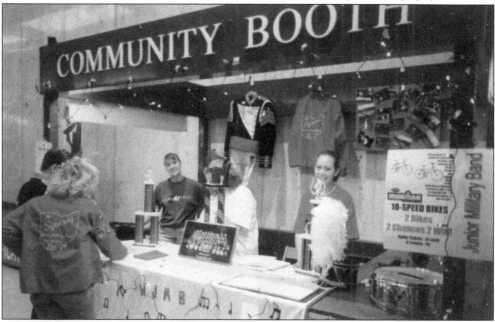

Members loved promoting the band. Here, they share music and memories from the 1998 tour featuring the music of Leonard Bernstein, including melodies from "Somewhere," the fanfare from *A Quiet Place, Slava,* "Ballet at the Village Vortex," "In Nomine Patris," and the *Candide Overture.* With the additional training, rehearsals, and performances, members often became leaders in their own high school bands. If performance dates conflicted, loyalty was to the school performance.

116

Throughout the band's history of making music throughout the United States, Canada, and Europe, nothing instilled a love of country and a feeling of patriotism more than playing some of Squire's favorites at Mount Rushmore and at local patriotic events. At the 1998 annual concert, the band dedicated "America the Beautiful" to Squire, "who we feel is one of the greatest men to ever live. A man who teaches music, but more than that, a man who teaches young people to have respect for their God and country needs to be recognized and acknowledged for his unending greatness . . . our mentor, our teacher, but most of all, our friend. Squire, we love you, and we thank you for all your love and guidance." (Courtesy of Bob Mayerchak.)

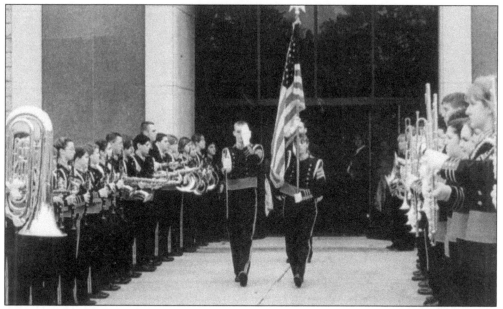

Renowned director Donald W. "Squire" Hurrelbrink passed away in March 1999. His celebration of life was filled with his music and memorabilia along with alumni, parents, colleagues, civic leaders, and friends. The memorial service at St. Paul's Lutheran Church in Warren was performed by alumnus Rev. Donald Cooper, band parent and deacon David Lewis, and Pastor Carl Jacobson of St. Paul's Lutheran Church. The band formed the honor guard at the cemetery, ending the service with "The Star-Spangled Banner" and "Taps" with echo. (Courtesy of *Tribune Chronicle*.)

Rick Muccio's caricature could not have said it any better. Squire was a fine musician, a caring humanitarian, and an extraordinary teacher. There are people in every part of the country who remember the gifts Squire gave to them—a love of music, a love of country, and the desire and tools to succeed. The 1999 annual concert was a tribute to Squire. As Jonathan Willis conducted "America the Beautiful," a slide presentation of Squire's life was projected above the band. (Courtesy of *Tribune Chronicle*.)

Staff and dedicated alumni with music degrees strived to continue the band's legacy. It was with a deep sense of reverence that the staff continued the labor of love that Squire so faithfully carried out for 66 years. Inspired by his example, they shared a sense of pride, tradition, and dedication to excellence that was reflected in rehearsals and performances. At right, from left to right, are Judy Cartwright, Chris Foster, Paul Sohayda, and Angie Maines. Others assisting the band musically during these years included Jonathan Willis, Mike Westmoreland, Chris Bennett, Carly Johnson, Dean Moore, and Tom West. Angie Maines, Holly Burns, and Carlie Donnelly created flag work. Paul Brizzi continued to assist and conduct through 2007. Over the years, band parents helped with fundraising and general management. With untiring devotion, Judy took over the travel planning, finances, and management of the band in the 1980s and continued through 2006. Other alumni helped thereafter. Shown below are flags in Traverse City.

Each year, the Ohio Arts Council selected a few arts programs and superior musical groups for recognition and financial support. WJMB was honored to be selected from 1993 to 2008. Noon-in-the-Park and Christmas concerts at Powers Auditorium and other locations became annual events. Favorite holiday selections included *Russian Christmas Music*, *Christmas Festival*, the *Nutcracker Suite*, "Little Drummer Boy," and often a Christmas sing-along. The band is pictured in Warren at a Riverwalk Amphitheatre performance for the Trumbull County Fine Arts Council.

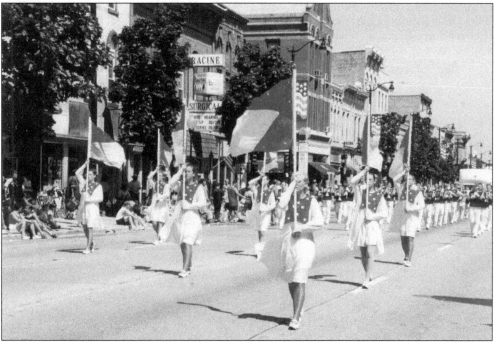

The band marched in several Racine Fourth Fest Parades in July in Wisconsin. Thousands lined the parade route, watched the field show competition, and viewed the spectacular fireworks display. This 1999 photograph clearly shows the patriotic image the band presented. Field show repertoire included "Fanfare and Allegro," "Amber Waves," and *Chester Overture*.

120

Alumnus Chris Bennett rehearses the percussion before leaving camp for a local performance. WJMB's 2000 show won top honors at the MACBDA championship in Traverse City. Featuring favorites from earlier years, the show included "Scream," "Where Is the Love," *Celebration Suite*, "Blowin' Off Steam," and "Land Race." That year, WJMB's 19th Annual Festival of Bands, showcasing 11 area bands, was held at Stambaugh Stadium.

In October 2001, a Tribute to the American Spirit was hosted by Youngstown State University. Jonathan Willis conducted the band in marches and patriotic selections. The finale featured "Stars and Stripes Forever" in a combined performance with the Youngstown State University bands. The patriotic 2001 field show was a musical salute to freedom. Selections came from *Dawn's Early Light*. As the show closed, the familiar strains of "The Star-Spangled Banner" made a majestic finale.

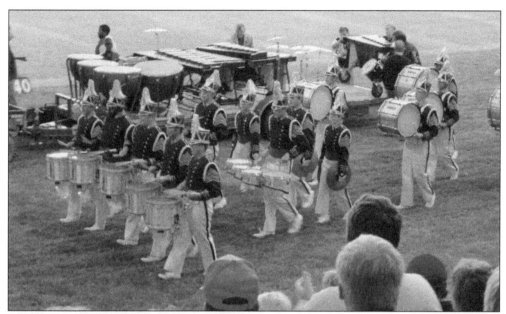

The band celebrated its 75th anniversary in 2002 with a field show entitled Southern Spirit. The music, arranged by Jonathan Willis, was inspired by Southern hymns and dances of the 19th-century American folk and hymn tune tradition. A successful MACBDA competition tour in 2003 featured Jonathan Willis's arrangement of Martin Ellerby's *Paris Sketches*, paying homage to four different Parisian locales. Percussion is shown passing in review after a show in Dakota, Illinois.

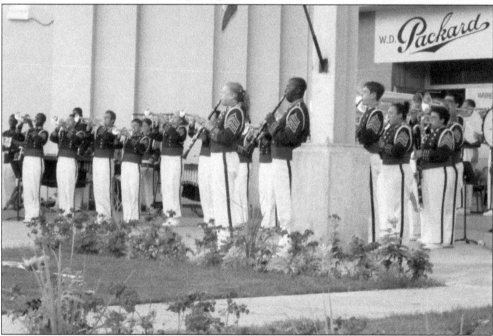

Outdoor concerts continued to be an important part of the band's summer performances whether in Warren, Buhl Park in Sharon, or other locations for community celebrations. Adding the covered stage area on the lawn entrance of Packard Music Hall provided a wonderful place for lawn seating and summer concerts. (Courtesy of *Tribune Chronicle*.)

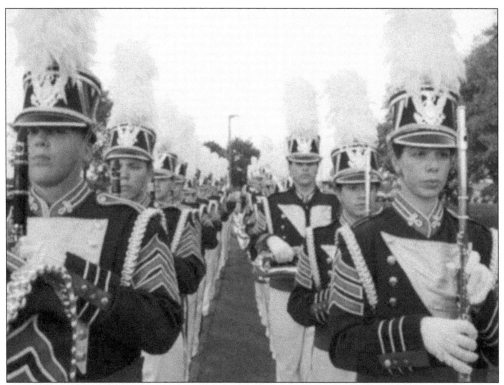

The four-week summer camp and performance tour included the 2004 field show American Hymnsongs, arranged by Jonathan Willis. Selections featured were "Fanfare and Hymn," "Hymn to the Fallen," "Exhilaration," and "Midnight Cry." The band is shown in Wisconsin ready and waiting for the introduction and announcement to take the field in competition.

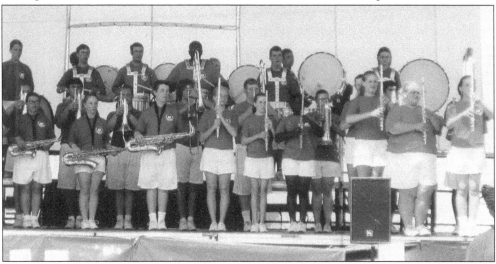

The band had a tradition of challenging students musically both in concert and on the field. In 2005, the field show music was based on Leonard Bernstein's popular comic opera *Candide*. Arranged by Jonathan Willis, selections included the "Best of All Possible Worlds," "Westphalia Chorale," "Make Our Garden Grow," and "Glitter and Be Gay." Shown here is a casual performance in Traverse City.

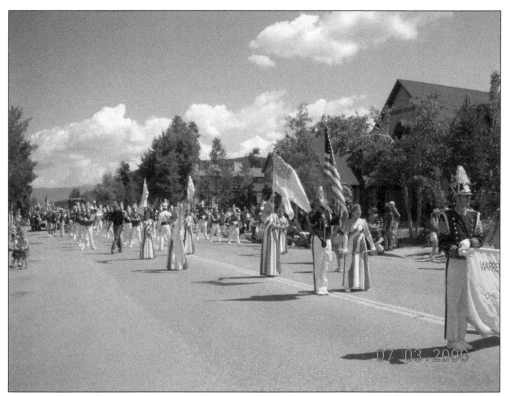

In 2006, after winning Class A competitions in all categories on the MACBDA circuit, the 40 members played a concert at Mount Rushmore and then traveled to Colorado for the Summit County Fourth of July celebrations in Dillon, Frisco, and Breckenridge. The band (seen here in Breckenridge) marched in parades in all three cities and played concerts at Dillon Marina and Breckenridge Riverwalk Concert Hall. Field music featured an arrangement of Joseph Curiale's *Awakening.* Field shows continued to be designed by Paul Brizzi from 1991 to 2007.

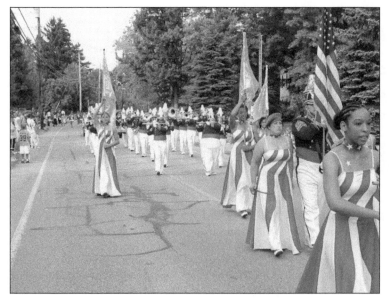

Local performances were at the very heart of the band throughout the years. Even with numbers dwindling, the band still fulfilled requests for parades and concerts such as this Cortland parade in 2007. When available, recent alumni assisted with local performances. In 2008, the band went on its last formal competition tour.

Numbers continued to dwindle, as did fundraising. The advent of state no-smoking laws coupled with the building of casinos in Ohio severely affected the band's ability to raise needed funds. A smaller but equally dedicated staff led by Carl Snyder and Lauren Monroe continued to provide instruction, with performances limited to small ensembles. Finally, in 2010, it was time. The WJMB Alumni Association donated instruments and percussion equipment to public schools in the area. Vehicles were sold and uniforms and flag equipment became part of local theater groups. The extensive music library was housed at a local high school with the understanding that area bands could borrow music and out-of-print selections.

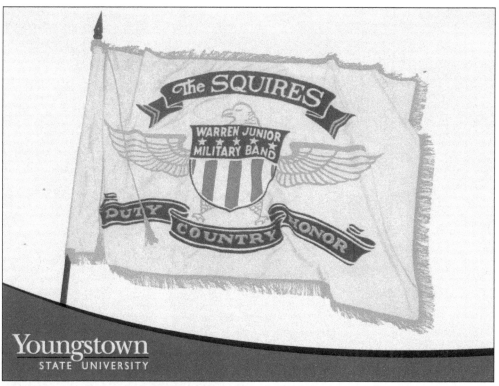

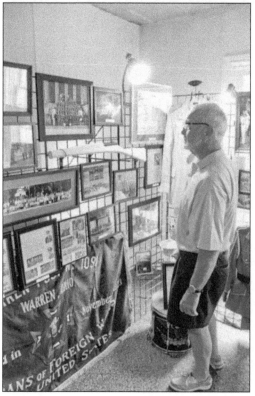

In 2014, the present alumni association, past alumni, and Herb and Janne Hurrelbrink-Bias donated over $70,000 to create a memorial scholarship for students at Youngstown State University's Dana School of Music. Many alumni, Dana students, and faculty were in attendance on September 19 as alumni president Jim Cunningham and the author shared highlights of the band's history and Squire's 66-year legacy of patriotism, loyalty, and dedication to music education. (Courtesy of Youngstown State University Foundation.)

The Warren Heritage Center revitalized the 1832 Kinsman House as a museum celebrating Warren's history. The WJMB Alumni Association has filled a room with photographs, trophies, and memorabilia over the years. Rob Pasha, a band member from 1961 to 1969, was one of the alumni attending the grand opening in June 2015. Viewing the many photographs, Rob found himself, and his wife, Ginny, located pictures of her father and uncle who were members of the 1930 band. (Courtesy of *Tribune Chronicle*.)

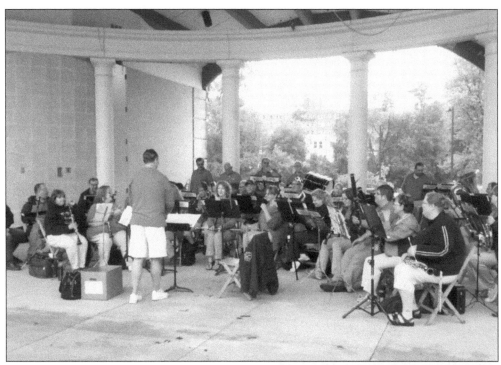

An alumni band was formed for a Trumbull County Fine Arts Council performance at Warren's Riverwalk Amphitheatre in September 2015 and to celebrate the band's new home for memorabilia at the Kinsman House. WJMB was always known for its patriotism, quality of concert music and field music, and marching style. Remaining true to the band's tradition, alumnus conductor Jonathan Willis selected "America the Beautiful," "Semper Fidelis," highlights from the *New World Symphony* and *West Side Story*, "Armed Forces Salute," "Father of Victory," and "Stars and Stripes Forever," and as always, ended the performance with "The Star-Spangled Banner." The excitement of playing together again brought alumni from as far away as Iowa and Missouri. The picnic after the morning rehearsal provided time to reminisce. A small group of alumni also performed in a September gala at the Kinsman House. It was a beautiful 83-year musical era. Lifelong band friendships and experiences will forever remain with members.

IT WAS A WONDERFUL BAND!
IT WAS A WONDERFUL LIFE!
CHERISH THE MEMORIES!

9 781540 226655